INDIA:
PIONEERING
PHOTOGRAPHERS
1850–1900

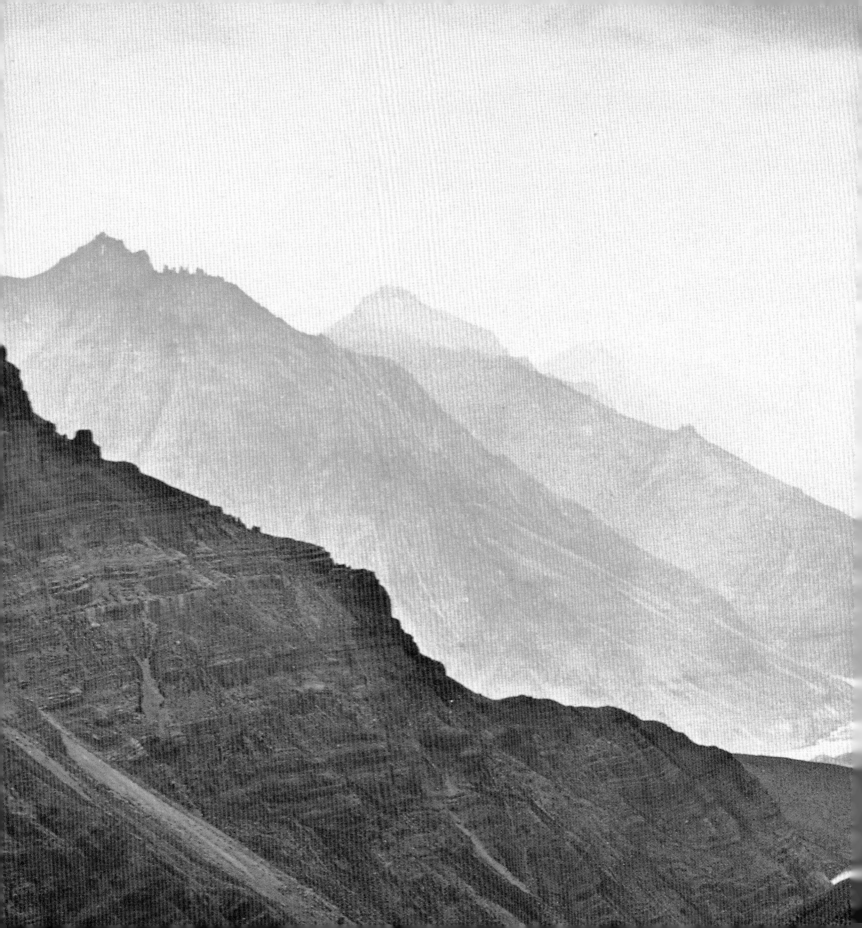

INDIA: PIONEERING PHOTOGRAPHERS

1850–1900

JOHN FALCONER

THE BRITISH LIBRARY
and
THE HOWARD AND JANE RICKETTS COLLECTION

This catalogue has been published on the occasion of the exhibition
India: Pioneering Photographers 1850–1900
held at the Brunei Gallery, SOAS, London 11 October – 15 December 2001

The exhibition is presented by Asia House, in association with The British Library
and the School of Oriental and African Studies, and sponsored by Royal & SunAlliance

HALF TITLE PAGE: *Portable photographic apparatus.* Engraving from
Gaston Tissandier, *A history and handbook of photography*
(2nd edn, London, 1878). British Library 08909.ee.48

TITLE PAGE: SAMUEL BOURNE, *Evening on the mountains –
view from below the Manirung Pass*, 1866 (cat. 102)

First published in 2001 by
The British Library
96 Euston Road
London NW1 2DB

British Library Cataloguing-in-Publication Data
A CIP record is available from The British Library

ISBN 0 7123 4746 1

Designed and typeset by Andrew Shoolbred
Printed in England by Balding + Mansell

Contents

Preface

The photographs in this exhibition are drawn from two major collections, that of the British Library and the Howard and Jane Ricketts Collection. A number were first seen in the exhibition *India Through the Lens. Photography 1840–1911*, curated by Dr Vidya Dehejia at the Sackler Gallery, Washington in 2000. While the inclusion of additional images reflects the personal predilections of the selectors and has resulted in a new exhibition which examines the subject from some different viewpoints, the organisers are indebted to Dr Dehejia for her original concept. On a practical level, it has also been possible to take advantage of the intensive conservation effort that the earlier exhibition involved, to make these photographs available to a wider audience.

The exhibition covers half a century of Indian photography, from around 1850 up to the turn of the twentieth century. As discussed later, Indian material from the 1840s is exceedingly scarce; it is only in the following decade that the medium established itself successfully and in succeeding years superseded the engraving and the lithograph as the prime vehicle of visual information about the subcontinent. The terminal point of the exhibition, the opening years of the twentieth century, comes as the primacy of the professional photographer was in the process of being eroded by a simpler and less cumbersome technology which allowed the untutored amateur fuller access to the medium. Images of the great Delhi Durbar of 1902–1903, organised by the Viceroy Lord Curzon with characteristic and grandiloquent panache, form a fitting close to this photographic survey. The camera was uniquely fitted to record this great celebration of British rule: it was probably the most photographed historical event in the subcontinent up to that date and attracted professional photographers from all over India.

But amateurs were also in attendance in significant numbers, precursors of a new era. In the half century that had passed between the first tentative attempts to use the camera in India and the growth of a vigorous amateur market, photographers had created a record, always fascinating and often of stunning beauty, of an endlessly diverse land. It is this record, which exploited to the full the expressive potential of the medium, which is celebrated in this exhibition.

The British Library's South Asian photograph collections owe their origins to material acquired by the East India Company and its successors from the mid-1850s onwards. While in some cases – primarily in the field of architectural and ethnological documentation – such material was actively commissioned, the collection, in common with most institutional archives, is heterogeneous in its nature, an accumulation of material in general reflecting no guiding principle beyond an acceptance of photography's value as a tool of record. Beyond this, it is difficult to discern in the nineteenth century any fixed acquisition policy beyond financial constraints. For example, the East India Company's foresight in purchasing at some expense a full set of Frederick Fiebig's unique series of early views of India in 1856 might be thought to represent an enlightened and prescient awareness of photography's unique importance as a visual medium, but it must be set against an off-hand refusal to buy a similarly comprehensive series of Felice Beato's photographs of India and China only a few years later. Our present perception of the aesthetic qualities of many of the images in the collection was largely incidental to the reasons for their original acquisition.

In contrast, the collection of Howard and Jane Ricketts reflects the individual taste and eye of the collector, more

actively concerned with the artistic quality of specific images and the physical condition of individual prints. Starting at a time when Indian photography was largely disregarded in the salerooms, their collection contains much that is unique and not previously exhibited: an early album of salt print views and portraits made by Alfred Huish between 1848 and 1852 is among the small body of work known from the 1840s, while a fascinating insight into social history is offered in the portraits of Calcutta society in an album compiled by John Constantine Stanley, ADC to the Governor General Lord Canning in the late 1850s. Their collection and identification of the work of Donald Horne Macfarlane has brought to light the work of one of the great originals of Indian photography in his magnificent series of landscape studies dating from the early 1860s. The inherent chemical fragility of nineteenth-century photographs makes them particularly vulnerable to yellowing and fading and to the loss of much of the rich tonality of their original state. A major criterion for acquisition by the Ricketts has always been fine condition, and the display of this material offers a rare opportunity to view works in a state which does full justice to the aesthetic and technical achievements of these pioneering photographers.

The selection of material for exhibition illustrates the achievements of nineteenth-century photographers in India on several levels, from the officially sponsored record to the consciously artistic statement. And if the two collections have widely divergent origins, the photographs themselves repudiate the myth that documentary records and works of art are mutually exclusive categories. The gathering together of material from these two different collections, one institutional, the other private, will also, it is hoped, lead the viewer to appreciate something of the fascinating range of subject matter and the dedication with which photographers attempted their task under often difficult circumstances.

The exhibition was organised by Asia House and thanks are due in particular to its Chairman Sir Peter Wakefield and to Katriana Hazell, Cultural Director, for all their work and enthusiasm and to Royal & SunAlliance for its generous sponsorship. The Brunei Gallery has provided a handsome venue to display this material and the organisers are indebted to the Director of the School of Oriental and African Studies for its use. Particular thanks are also due to John Hollingworth, manager of the Brunei Gallery, for his unfailing and enthusiastic help in the planning, design and installation of the exhibition.

Within the British Library, Beth McKillop played an invaluable role in the early stages of planning and has continued to advise and help throughout. Her assistants Lydia Seager and Penny Rowland have administered the movement and preparation of photographs for display. British Library material was skilfully conserved and mounted in the Library's Oriental Conservation Studios by Robert Davies and Ian Swindale under the management of Mark Barnard. Annie Gilbert, Curator of Photographs in the Early Printed Collections, sourced material for exhibition from the Library's Humanities Collections. The forbearance of my colleagues Jerry Losty, Jennifer Howes and Helen George in the Prints, Drawings and Photographs Section of the Oriental and India Office Collections during the preparation of this exhibition is also gratefully acknowledged. This catalogue was designed by Andrew Shoolbred and produced to a very tight schedule under the editorial control of Lara Speicher of the British Library's Publications Department.

While the photographs in this exhibition have been drawn primarily from the two collections noted, special thanks are also due to Ebrahim Alkazi for generous access to his collection over a long period and for the loan of two albums of photographs by James Waterhouse. Michael Gray kindly lent nineteenth-century camera equipment for display.

I am also grateful to Ebrahim Alkazi, John Fraser, Sophie Gordon, Michael Gray, Dr George Michell, Maria Antonella Pelizzari, Dr Christopher Pinney and Howard and Jane Ricketts for past and continuing discussions relating to photography in Asia.

John Falconer
CURATOR OF PHOTOGRAPHS
ORIENTAL AND INDIA OFFICE COLLECTIONS
THE BRITISH LIBRARY

Pioneers of Indian Photography

> India presents to us perhaps as fine a field as any single country in the world. It contains a perfect specimen of all the minute varieties of Oriental Life; of Oriental Scenery, Oriental nations and Oriental manners, and it is open to us to explore these peculiarities to the last degree while enjoying a perfectly European security. There is a deep and growing interest now felt in Europe in every thing Indian...[1]

Thus the Rev. Joseph Mullens, in a paper given to the Photographic Society of Bengal in October 1856, expressed his sense of the inexhaustible photographic potential of the subcontinent. But while praising the way in which members of the recently formed photographic societies of Calcutta, Bombay and Madras were 'endeavouring to collect information and to register experience respecting the peculiarities which attend the practice of Photography in India,'[2] he detected a 'want of purpose' and organisation among the amateur photographic community and proceeded to outline a comprehensive scheme of operations 'more complete and more systematic' than had hitherto been attempted. Little escaped Mullens' notice in this programme: astronomy, botany, medicine, the criminal courts and the prison service, public works departments – every branch of science and administration could benefit from the 'stern fidelity of photography' in furthering knowledge and 'promoting economy and efficiency'. Beyond such practical applications, he also envisaged the creation of a detailed record of the cultural and ethnic diversity of the country, its topography, architecture, trades and types, encompassing in effect, 'every variety of minute and distinctive detail presented by the country and people around us.' While Mullens' 'perfectly European security' was to be shattered the following year in the rebellion which engulfed Northern India, his photographic predictions proved more durable. In the second half of the nineteenth century, photographers in India, both amateur and professional, were to produce the most extensive and artistically distinguished record of the land and peoples of any country outside the metropolitan centres of Europe and America.

Mullens' words were to be echoed a decade and half later by the architectural historian James Burgess who, in the preface to a volume of views of Gujarat and Rajasthan published in 1874,[3] noted

the 'growing taste...slowly spreading among Europeans for works illustrative of the architecture, scenery, races, costumes, etc.,' of India. By this time, photography had been feeding this appetite for over twenty years and had largely superseded paintings, engraving and lithography as the prime vehicle of visual information about the subcontinent. Photographic studios – Indian and European – were by now well-established in the major cities and surviving albums of prints provide evidence of a flourishing trade in tourist views of the country and peoples of India. Much of the achievement of these early years can be credited to the early pioneers, the majority amateur in the first decades, who laboured, often in the face of great difficulty, to create a lasting photographic record of a vast and diverse land.

While the pattern of photography's growth in the Indian subcontinent broadly kept pace with developments in the wider world, local factors contributed to the creation of a characteristically Indian body of work: first, the very immensity of the country and the variety of its peoples provided, as Mullens had pointed out, a unique source of images. In addition, the presence of a small European population exercising political control formed a market for particular types of work which reflected a vision of the country and its people palatable to Western sensibilities and preconceptions. Indian photographers added a further dimension as they adapted the medium to their own cultural requirements. The development of photography in the subcontinent and the accompanying influence of these factors can perhaps best be understood if broken down into a series of convenient, if broad and overlapping chronological periods, each characterised by the dominance of particular themes in the work produced.

While there is evidence of photographic activity in India from soon after the public announcement of the daguerreotype in Paris in August 1839, this does not appear to have taken place on any large scale and definitely dated early examples are scarce. During the 1840s only sporadic attempts appear to have been made to establish commercial photographic studios in the subcontinent, and few of these pioneers appear to have survived for long, many doubtless succumbing to disillusion with a medium which, in inexperienced hands, often failed to live up to early grandiose claims. Photography became more firmly rooted in the 1850s and while several studios were established then, the decade was dominated by the amateur photographer, largely preoccupied with the artistic potential of the medium and unconcerned with commercial considerations. The mid-1850s in particular saw a remarkable efflorescence of photographic activity, typified by amateurs working the paper negative processes, the dissemination of photographic knowledge through the establishment of photographic societies in the three Indian presidencies,[4] and active government sponsorship of photography. The finest products of this decade, seen in the work of photographers like Dr John Murray and Linnaeus Tripe, stand comparison, both aesthetically and technically, with images produced anywhere in the world in the same period.

A growing market saw an acceleration in the production of views and portraits by commercial photographers in the following years. But with the exception of a few outstanding and intrepid photographers like Samuel Bourne, the 1860s in general saw a lessening of creative quality as work became increasingly geared to satisfying a larger and less critical audience. In the four decades from the early 1860s to the 1890s the professional reigned supreme, and produced during this period a vast amount of material which filled the albums of visitors and residents, but which was only rarely of any outstanding quality. But this professional hegemony was now challenged by the development of a simpler photographic technology from the late 1880s which encouraged more and more people to make their own photographs. Photographers' advertisements from the 1890s onwards show a growing awareness of this trend, as many turned to the sale of cameras, films and other supplies, and the supplying of processing facilities for amateurs. The professional photographer continued to be in demand for the recording of important events and for some, postcard production made up for the loss of revenue from the sale of landscapes and views. But by the turn of the twentieth century a new photographic tradition had begun to emerge and by the close of the First World War only a handful of the old professional studios remained in business. But for fifty years photography had illuminated the Indian scene from many differing angles and perspectives, and in the hands of its more inspired practitioners had created works of enduring artistic and documentary value.

Colesworthy Grant, *William Brooke O'Shaughnessy, Professor of Chemistry and Natural Philosophy, Medical College, Calcutta.* Lithograph, British Library.

Artists and Amateurs: the Early Years of Photography in India

While it is unlikely that we will ever know with certainty who took the first photograph in India, it is clear that the European excitement over the announcement of the new medium in Europe in the summer of 1839 quickly transferred itself to India: descriptions of the daguerreotype process,[5] sufficiently detailed to make practical experimentation a possibility, were appearing in the Indian newspapers by the end of the year,[6] and scattered references indicate the existence of photographic activity from this time on.[7] A convincing possible claimant for the title of the first photographer in India, is Dr (later Sir) William Brooke O'Shaughnessy (1808–1889) of the Bengal Medical Service, who as early as October 1839 had clearly been experimenting for some time

with photogenic drawing, using the light-sensitive properties of gold rather than the more commonly used silver compounds. In a tantalisingly brief account of a meeting of the Asiatic Society of Bengal in Calcutta, members' attention was drawn to the 'series of experiments he had lately made on the art which was exciting so much attention at home – namely Photogenic Drawing – and his experiments were all successful'.[8] O'Shaughnessy clearly redirected his work in the light of Daguerre's announcement and by early 1840 had mastered the daguerreotype process.[9] On 4 March 1840 several examples of this 'very simple yet very unintelligible' process were shown to members of the Asiatic Society:

> Several drawings were exhibited to the meeting, of the Esplanade and other parts of Calcutta which had been taken by him. In one part of the drawings a black speck was observable to the naked eye, but with a microscope of great power it would be seen that the speck represented a kite which was at that moment perched [on] the building – and though so small, even the wings and tail of the bird could, with a lens be easily distinguished so minute and yet true to life was the picture...[10]

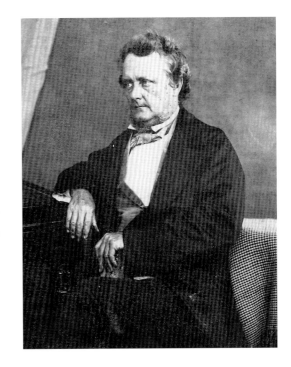

Unknown photographer, *Josiah Rowe, Calcutta*, *ca.* 1860. Albumen print, Howard and Jane Ricketts Collection

This awed response to photography's apparently magical ability to reveal the incidental details of the physical world with a promiscuous minuteness unavailable to the human eye alone, together with the lack of a specifically photographic vocabulary to describe the new phenomenon ('drawing' and 'sketch' would be commonly applied to photographic images for years to come), echo precisely the impact of the daguerreotype in Europe. A demonstration and explanation of the process at one of the *soirées* held by Lord Auckland at Government House, Calcutta in May 1840 attracted further interest,[11] but this appears to have waned in succeeding years as the novelty of the medium wore off. O'Shaughnessy's work (examples of which have not so far come to light) is one of the few pointers to photographic activity in India during this decade: difficulties in obtaining supplies of fresh chemicals, the lack of skilled teachers and the many problems of working in an unforgiving climate (all of which were to be causes of complaint for the next twenty years) are no doubt largely responsible for the paucity of surviving images from the 1840s. However, amateurs clearly continued to work throughout the decade. Josiah Rowe, for instance, acclaimed by his contemporaries as 'the oldest photographer in Calcutta',[12] was active in the early 1840s and continued to take pictures

well into the 1860s.[13] A few short-lived professional studios also emerge in the early 1840s (such as F.M. Montairo in Calcutta, who in 1844 was briefly advertising his willingness to 'take likenesses by the daguerreotype process'[14]), and the occasional image has survived from transient visitors such as the French customs official Alphonse Itier (1802–1877), who visited India on his way back from China in 1845. But it was the first appearance of professional photographers in the commercial directories at the end of the decade that heralded the arrival of the commercial operator as a permanent presence in the subcontinent (although the medium's uneasy lack of defined status is indicated in the 1849 listing of F. Schranzhofer's Calcutta studio – 'Calotipist [sic], takes photographic likenesses on paper' – under the heading of 'Artists'.[15])

At the start of the new decade, the work of the German calotypist Frederick Fiebig starts to blur the distinction between amateur and professional and also points towards the future dominance of photography over the other graphic media. Fiebig was active as an artist and lithographer in Calcutta in the second half of the 1840s, but in about 1849 he took up photography and in the next five years or so produced an extensive portfolio of calotype views, the majority taken in Calcutta and its environs, but also including Madras, Ceylon (Sri Lanka), Mauritius and Cape Town (these last

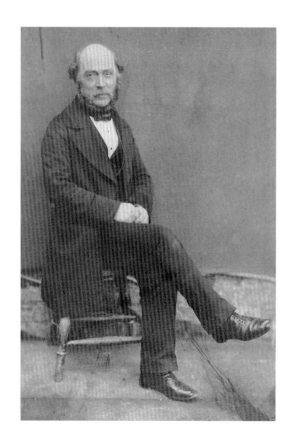

Unknown photographer, *Aaron Penley, Professor of Civil Drawing, Addiscombe College*, 1859. Penley (*ca.* 1806–1870) taught at the East India Company's seminary from 1850–1861, and introduced photography in the courses there in the mid-1850s. Albumen print, British Library OIOC Photo 42 (98)

presumably made during the voyage back to Europe), a complete set of nearly five hundred of which, in the form of hand-coloured salt prints, was purchased by the East India Company for £60 in 1856.[16] In an article which appeared during a visit by Fiebig to Madras in 1852, the writer refers to views of China and Burma as well as India and states that Fiebig showed him '7 or 800 views of Calcutta and 60 or 70 of Madras, which had been taken with the greatest accuracy and detail'.[17] No views of China and Burma by Fiebig have come to light and the figure of 800 for his Calcutta work seems unlikely,[18] but the collection represents one of the earliest extensive photographic records of Calcutta and Madras, the former of particular interest since, unlike the majority of photographers of the city, Fiebig did not restrict his activities to the European section of the city bordering the Maidan. In his correspondence with the Company Fiebig states that his pictures were taken in his 'leisure time', but such an investment of effort and material argues a more than amateur interest in photography, and the account of his visit to Madras wishes him 'a large sale both in Europe and in India, for the sketches which he intends to publish.'[19]

While the 1850s were to see the permanent establishment of professional studios, particularly in the larger urban centres of Calcutta

and Bombay, for a further decade photography in the subcontinent was dominated by amateur efforts. Writing in the mid-1850s, the Bengal Army surgeon John McCosh (1805–1885), himself a practising photographer whose images in the National Army Museum and the Victoria and Albert Museum are among the early examples surviving from the subcontinent, recommended the study of photography to army officers – 'in all its branches, on paper, on plate glass, and on metallic plates' – as a satisfying and instructive pursuit, by which 'he may make such a faithful collection of representations of man and animals, of architecture and landscape, that would be a welcome contribution to any museum.'[20] Photography's qualities as an instructive pastime, combining potential for artistic expression with the practical merits of information gathering, were a constant refrain in the reports of meetings and exhibitions held by the photographic societies established in all three presidencies in the middle years of the decade. Bombay was the first, an inaugural meeting being held in October 1854, at which the chairman, Captain Harry Barr of the 8th Bombay Native Infantry, outlined the vast range of subjects available to the photographer, from the country's 'magnificent scenery – its temples – palaces – shrines' to the 'varied costumes, characters and physiognomies of its millions of inhabitants', whose peculiarities could only be fully delineated by an 'Art, of which the beauty and utility are only surpassed by its truthfulness'.[21] In addition to their function as a

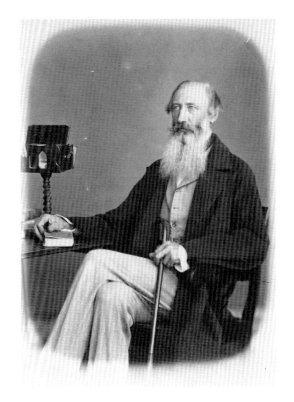

Unknown photographer, *Dr John Murray, Agra,* ca. 1860. Albumen print, British Library OIOC Photo 835 (389)

forum for the exchange of practical photographic information, all three societies maintained an active programme of exhibitions during the 1850s, which served to raise public awareness of and familiarity with the medium, thus laying the foundations for the growth of commercial photography in the following decade. Meetings of the Photographic Society of Bengal were well reported in the local press and by 1857, under the patronage of Lady Canning, it could boast a European and Indian membership of around 120, the majority of whom were active photographers. In its exhibition of that year over 460 photographs were on display. Such activity not only served as a technical and artistic forum for photographers themselves but also, when the administration became actively interested in photography as a means of documentation, provided a conduit between the photographic community and officialdom. Official encouragement of and tuition in photography from the mid-1850s resulted in impressive work produced by officers who had taken up photography as a hobby and also found it professionally useful.[22] Almost all the most distinguished names in Indian photography in the 1850s and 1860s maintained links with the societies either as members, committee officials or contributors

to exhibitions. The work of probably the most accomplished amateur photographer in India in the 1850s, Dr John Murray (1809–1898) of the Bengal Medical Establishment, was seen at the exhibitions of both the Bengal and Madras societies. He had begun photographing in about 1849 and in the intervals of a busy career produced hundreds of large-format paper negatives, mainly of the architecture of Northern India and particularly of the Mughal architecture of Agra, Fatehpur Sikri and Delhi. Many of the original negatives survive in fine condition and demonstrate a very high level of technical skill, while his magnificent softly toned prints provide an unparalleled record of these sites.[23]

A Record of Conflict: Photography and the Rebellion of 1857

While the upheavals of the Indian 'Mutiny' or Rebellion of 1857–1858 in Northern India may have overshadowed the concerns of amateur photography, they inspired a number of photographers (Murray among them) to record the scenes of these cataclysmic events.[24] The most celebrated of these was the Italian professional Felice Beato – in partnership with James Robertson in the Middle East at the outbreak of the rebellion – who arrived in India in February 1858.[25] By this time the military campaign was largely over and Beato's record was confined to portraits of the more prominent participants and views of the buildings whose shattered remains bore the imprint of battle. Photographic technology would not of course at this date have allowed the recording of the heat of battle even had he arrived in its midst, but the fact that the campaign was largely over by the time of his arrival allowed Beato to tour the centres of action – primarily Cawnpore, Lucknow, and Delhi – and create an organised series of views. Unhampered by the exigencies of military movement, this appears to present a conspectus of the campaign reflected in its material remains. This seemingly objective record of the topography of war begs a number of questions, not only about the selection of subjects for inclusion in what implicitly purports to supply a comprehensive narrative of the campaign, but in the very authenticity of the images themselves. Modern research has established beyond reasonable doubt that Beato's celebrated photograph of the interior courtyard of the Sikandarbagh at Lucknow, strewn with the bones of some of the 2000 Indians killed in its recapture, was a recreation rather than a record of the event: by the time of his arrival the area had been cleared of bodies, but in order to evoke the carnage Beato did not scruple to restore these grim reminders of battle to the scene.[26] A contemporary review of Beato's Lucknow photographs, twenty-six of which which were shown at the Photographic Society of London's 1858 exhibition, noted the documentary significance of these views, but also praised them as vivid records of 'the pictorial romance of this terrible war'.[27] If to the modern eye the historical importance of these visual documents remains undiminished, the passage of time has somewhat dissipated the evocative intensity of the

images. But to a news-hungry public for whom these events represented an intolerable outrage still hot in the memory, such photographs were steeped with resonance and depth of meaning.

Similar responses attached themselves to the work of other photographers who, after the suppression of the uprising, used photography to record the physical imprint of the events of the preceding months. Robert Tytler, whose wife Harriet had been present throughout the siege of Delhi, learnt photography in order to help his wife with a panoramic painting of the palace at Delhi which she was preparing. After receiving some tuition from both John Murray and Felice Beato, and no doubt influenced by their work in recording the sites of the Mutiny,[28] the couple produced in the space of six months a collection of over five hundred large paper negatives, which, when shown to a meeting of the Photographic Society of Bengal won praise as 'unquestionably the finest ever exhibited in Calcutta...[embracing] every scene of the mutiny of 1857, from the cavalry lines at Meerut to the Residency at Lucknow'.[29] Clearly as important in the writer's mind as their aesthetic qualities were the more immediate associations attached to such photographs as the 'painfully interesting views of Cawnpore, the Ghaut at which the boats were attacked; the well; and the side of the house in which the ladies and children were murdered'.[30] Indeed, for the remainder of the century, the principal sites of the mutiny – the Residency at Lucknow, the well at Cawnpore, and other scenes representative either of the triumph of British arms and fortitude or the deepest Indian perfidy – achieved an iconic status: stock items in the portfolio of virtually every commercial photographer which find their place in the albums of almost every visitor to the subcontinent well into the twentieth century.

'The Great Object, the Preservation and Illustration of the Monuments of India'

> Again, what resources in the hands of an archaeologist, are the views of buildings in distant countries! The marvels of Athens and of Rome, the inimitable richness of the monuments of India, the bold architecture of Egyptian temples, can be kept in his portfolio, not modified and disfigured by an untrustworthy pencil, but such as they are in reality with their beauties, their imperfections, and the marks of destruction which time has engraved upon them. Photographic prints are mirrors from which are reflected the banks of the Nile and of the Indus – the buildings and the landscapes of all the countries through which the camera has passed.[31]

The British presence in India extended back over two centuries by the time of photography's appearance. And following the arrival of the first English professional artist William Hodges in

1780, a steady stream of painters and draughtsmen visited India in search of picturesque and romantic subjects. Of these, the most famous was the artistic partnership of Thomas and William Daniell, who between 1786 and 1794 travelled the length of the subcontinent sketching the views that were later published as aquatints in their six volumes of *Oriental Scenery*. Accompanying such artistic endeavours were the scholarly investigations of men like Sir William Jones in the last quarter of the eighteenth century, who, in laying the foundations for the European study of India's complex cultural, linguistic and racial history acted as a bridge between the two worlds. And just as photography was destined to supersede artists like the Daniells in recording the scenic splendours of the subcontinent, so it was also to play a significant role in supporting scholarly investigations in fields such as anthropology, archaeology and epigraphy.

During the first half of the nineteenth century the recording of archaeological sites had been left largely in the hands of amateur enthusiasts and artists, several of whom produced valuable if often unsystematic collections of drawings and plans. As the significance and sheer volume of India's surviving monuments became more clearly apparent, so the East India Company's responsibilities in this area became more evident and the authorities began to encourage an organised approach to the investigation and upkeep of important sites and buildings. In 1847 the Governor-General was instructed from London to institute a preliminary programme of listing that would eventually lead to 'a general, comprehensive, uniform, and effective plan of operations based on scientific principles', which in turn, it was hoped, would pave the way towards 'the great object, the preservation and illustration of the Monuments of India.'[32] This early initiative faltered in succeeding years, but renewed interest in the monuments of India coincided with the spread of photography and resulted in an upsurge of interest in the medium both as a means of artistic expression and as a documentary tool. One important example of the way in which photography was used in the task of recording India's architecture and archaeology illustrates this development clearly.

In response to the 1847 despatch, the Bombay Branch of the Royal Asiatic Society had formed a commission to list and document the cave temples of Western India. On the commission's recommendation the Bombay Government in 1851 sanctioned the employment of the 'portrait and animal painter' William Armstrong Fallon, 'for the purpose of making accurate copies of the sculptures of the caves of Elephanta'.[33] While Fallon's output was of high quality, and a number of his paintings were shipped back to England, it was soon realised that to perform such a massive task comprehensively would not only be hugely expensive but would make little impact on the huge number of sites meriting similar treatment. As the Court of Directors had pointed out in 1847, to illustrate the two dozen most important cave sites of Western India alone would take a single artist an estimated thirty-two years![34] Fallon's contract was extended several times, but in 1854 the Directors called a halt to this seemingly endless project and drew attention 'to the use of photography on

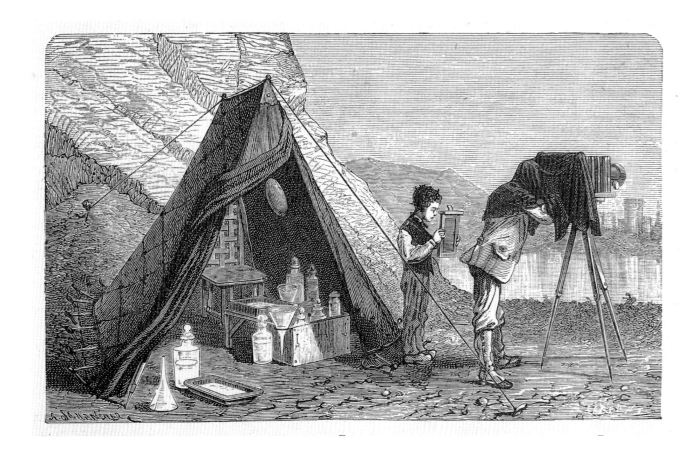

Photography and Exploration. The wet plate photographer at work in the field. Engraving from Gaston Tissandier, *A history and handbook of photography* (2nd edn, London, 1878). British Library 08909.ee.48

paper, to expedite and economise the labours of the Cave Committee'. For such work, it continued, 'we may mention that Captn. Biggs of the Bombay Artillery, to whom we presented an apparatus for the purpose, has satisfied us of his competency to undertake photographic works of the required description.' And in more general terms, the directors professed themselves keen to encourage 'the study of this useful art in any of the scientific or educational institutions, under the control or influence of your government, and we shall be prepared to furnish you with the requisite apparatus if you find it necessary to procure them from this country.'[35]

Thomas Biggs (1822–1905) of the Bombay Artillery took up his appointment as architectural photographer in early 1855 and in the course of that year made over 100 paper negatives of Bijapur, Aihole, Badami and other sites in Western India. The resulting prints were enthusiastically reviewed and displayed by his contemporaries in the Photographic Society of Bombay, but his work was cut short by the army's insistence that he return to regimental duties. On Biggs' own recommendation, he was replaced by William Harry Pigou (1818–1858) of the Bombay Medical Service, who from December 1855 until early 1857 (when he too was recalled to military duties) continued the

photographic documentation of sites in the Presidency. While the authorities in London had praised Biggs' work as displaying 'the highest merits as works of art',[36] his military superiors were more concerned with his availability for duty: in the cases of both officers, their work was hampered and finally curtailed by the army's reluctance to release manpower for what it evidently considered a non-essential activity at a time of staff shortages for military duties. The work of Biggs and Pigou was not wasted, however, for a decade later in 1866 a good part of it was made available through the publication of three books, illustrated with original photographs, on the architecture of Bijapur, Dharwar and Ahmadabad, an expensive venture only made possible by the sponsorship of Indian philanthropists and produced by the London publisher John Murray.[37]

The same documentary concerns intermittently stimulated the Madras authorities, also attracted by photography's much-vaunted advantages of 'perfect accuracy, small expenditure of time and moderate cost',[38] but a similarly erratic pattern of enthusiasm succeeded by retrenchment followed the photographic activities of Linnaeus Tripe (1822–1902). Tripe had acted as official photographer with the government mission to the Burmese court at Ava in 1855 at the conclusion of the Second Anglo-Burmese War, and the portfolio of one hundred and twenty atmospheric views of Burma which resulted led to his appointment as Madras Presidency Photographer in October 1856. In a remarkable burst of activity during a tour lasting from December 1857 to April 1858, Tripe photographed the temple architecture of, among other places, Srirangam, Tiruchirapally, Thanjavur, Madurai and Pudukottai: the published volumes of his photographs[39] amply demonstrate an 'ambition to practice photography for some really useful purpose',[40] and contain some of the finest examples of nineteenth-century architectural photography. But as had been found in Bombay, a truly comprehensive record required greater commitments of time and money than had at first been anticipated, and Tripe too fell victim to demands for his return to military duties, and to the financial economies of the Governor, Sir Charles Trevelyan, who considered the employment of a full-time photographer 'an article of high luxury...unsuited to the present state of our finances.'[41]

While the work of both Biggs and Tripe was conceived as the production of a documentary record of architectural monuments, the implicit underlying motivations and preconceptions which coloured their work also played a significant part in their photographic vision. In a country the size of India, personal knowledge of the whole country and its wealth of remains was clearly beyond the reach of a single scholar. Thus, when the architectural historian James Fergusson came to publish his *History of Indian and eastern architecture* in 1876, he acknowledged that 'for the purpose of such a work as this...photography has probably done more than anything that has been written.'[42] But for Fergusson, as for many another nineteenth-century scholar, the architectural record was not primarily a matter of aesthetic history, but was, in the absence of extensive surviving written records, an historical document, 'a great stone book, in which each tribe and race has written its

annals and recorded its faith.'[43] And this in turn was of the greatest possible importance in the colonial context, as a source of information for those 'who wish to know who and what the people are or were, whom we have undertaken to guide and govern.'[44] Such assumptions inevitably coloured the approach of those whose task it was to undertake the work of photographic documentation. Biggs' reports of his activities reveal both the urgent need for the work of documentation as well as something of his own character. At one site, the changes which had taken place since an earlier visit were all too evident, 'the best sculptures having been taken away, and several of the best temples having disappeared altogether'. And while he was fully alive to the beauty of many of the temples, he exhibited a typically Victorian response to the erotic nature of some of the sculptures he encountered, pointing out that they afforded 'another proof of the early date at which the morals of India assumed such a headlong and downward tendency,' and noting that it was to have been his intention, had he remained longer in the post, 'to have applied...for authority to have them effaced wherever I found them.'[45]

In Tripe's case, the text accompanying his published photographs broadened their significance beyond architectural record, contextualising the images to support a positive message of material progress under British rule after the upheavals of the Mutiny in Northern India. Of Tripe's view of the irrigated and cultivated land surrounding Rayakota Hill, for example, J.A.C. Boswell of the Madras Civil Service writes in the accompanying letterpress that in the photograph 'everything speaks in language that cannot be mistaken, that a brighter day has already dawned in India,'[46] while the ruins of the fort at Palakoddu were a solemn and picturesque reminder 'of the anarchy which generally prevailed' in earlier periods of Indian history, compared to 'Christian European Civilisation' which would 'make the influences of her Government manifest in their social, moral, and political advancement.'[47] Thus photography could be used to point a moral in two directions simultaneously: backwards to a history of political decay and economic stagnation, and forwards to an era of stability and progress under British rule.

After the abolition of Tripe's post, the photographic impetus lapsed for a decade. In 1867, however, the Government of India returned to the subject: instructions were again issued, drawing the attention of officials to 'the desirability of conserving ancient architectural structures...and of organizing a system for photographing them'. The Governor-General was initially of the opinion, no doubt for reasons of economy, that the employment of professional photographers was an unnecessary luxury, and that the work could be carried out to suitable standards by 'competent amateurs'.[48] This advice was fortunately ignored by the governments of Madras and Bombay who in 1867–1868 employed the professional photographer Edmund David Lyon to take a series of architectural views which retain both their artistic and documentary importance. As a preliminary step it was resolved in the following year that in future, every annual administration report should

contain a separate chapter on archaeology.[49] Lists of important structures duly started to come in, but the disappointing response to the request for photographs indicated that in most outlying districts the assumed reservoir of amateur talent either did not exist, or the results were not of sufficiently high quality to serve as archaeological records.[50] In this initiative, photography was seen as one part of a more detailed programme of documentation, measurement, conservation and repair.[51] To this end the Government of India authorised the establishment, on an experimental basis, of teams of craftsmen who would visit specific sites, make measured drawings and plans, take plaster casts of architectural details and decorations and produce a comprehensive photographic record. In Bengal, the results of the first expedition, to the Bhubaneshwar temples in 1868, were disappointing from the photographic point of view, but in the Bombay Presidency a more successful trip was made to the Ambernath Temple, where Shivshanker Narayan produced about thirty-five negatives which still survive.

In 1870, the often uncoordinated efforts to document the historical architecture of the subcontinent became formalised in the creation of the Archaeological Survey of India, the official body which continues to the present day to be responsible for the protection of India's historic sites. Major-General Alexander Cunningham, the first Director-General, was fully aware of photography's place as an integral and invaluable recording tool in the Survey's work, and while professional photographers had continued to be employed on archaeological work from time to time, by the 1870s it was becoming increasingly common for archaeologists to undertake their own photographic work. This shift of emphasis is most clearly seen in Cunningham's remark that he was 'especially anxious to obtain a photographer as assistant' in the survey, and the subsequent appointment in 1880 of Henry Bailey Wade Garrick, whose chief recommendation was his photographic skill rather than his archaeological experience.[52] Perhaps the most noteworthy of this generation of photographer-archaeologists was Henry Cousens, who in addition to a long and distinguished career with the Archaeological Survey in Western India, was also a remarkable architectural photographer, whose images illustrate many of his own published works. By the time of his retirement in 1910, however, the use of cumbersome large-format cameras was giving way to more portable equipment and the elegant and considered compositions of the nineteenth century were making way for more informal and hastily produced views.

Face to Face: Photographing the Peoples of India

On his appointment to the post of Presidency photographer in 1856, Linnaeus Tripe had not intended to restrict the subject matter of his work solely to built structures. In a letter outlining his

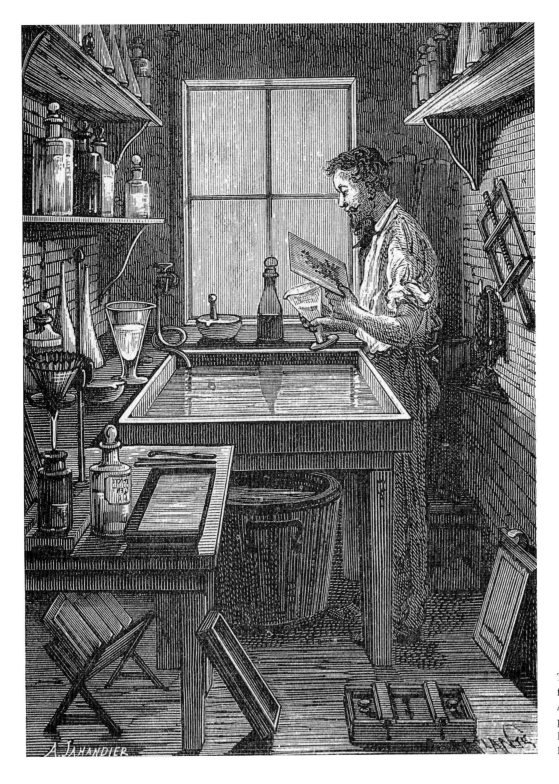

The dark room. Engraving from Gaston Tissandier, A history and handbook of photography (2nd edn, London, 1878). British Library 08909.ee.48

plan of work, he envisaged the creation of a photographic record that would encompass not only the architecture of Southern India, the natural products of the country and its topography, but which would also include 'illustrations of the races under this government, of their customs, dress, occupations'.[53] This ambitious plan never in fact materialised, and Tripe's work before the abolition of his post is almost entirely architectural, but such a programme concurred implicitly with James Fergusson's view of the intimate connection between the archaeological and ethnographical record. As with architecture, the peoples of India suggested a natural area for documentation and within a few years the creation of visual records of the diverse cultural and racial composition of the subcontinent had become a photographic genre in it own right. Whether in the service of the rising science of ethnology, or as the creation of 'exotic' souvenirs of the East, photography of racial types became, alongside architectural photography, the most important of the 'officially' sponsored uses of the medium.

The value and meaning of such visual records, both as an accurate tool for comparing different races and as an artistic pursuit, had been debated since the early days of photography. After a slow start, this form of documentation was pursued in India with particular energy. When in 1857 the Bombay photographer Dr Narain Dajee contributed an extensive series of such portraits to the Photographic Society of Bengal's exhibition, the organisers noted that 'the castes and costumes of the natives of the country have not yet received...that attention which they deserve, and which they will no doubt in time obtain.'[54] But by the time this was written, two Bombay photographers, William Johnson and William Henderson, had already started to make good the deficit, contributing a series of studies of the inhabitants of Bombay and surrounding districts to the monthly publication, *The Indian amateur's photographic album*,[55] a work issued under the patronage of the Bombay Photographic Society. Some of these photographs later found more permanent form in a two-volume work by Johnson who, declaring that 'photographic delineations of the numerous peoples and tribes frequenting...Bombay...have long been desiderata both among students of geography and ethnography, and the lovers of art,' published *The oriental races and tribes, residents and visitors of Bombay* (2 vols, London, 1863–1866), containing a series of portraits of racial and caste groups, using montage techniques to place them against appropriate backgrounds.

Johnson's book was the first photographically illustrated ethnographical publication to appear in India. By this time the subject had started to become a popular one among commercial photographers, catering on the whole to a European market more interested in exotic studies than scholarly precision. Yet the late 1850s also saw the growth of this type of photography in a more explicitly scientific context. The formation of ethnological societies in Europe in the 1830s and 1840s focussed attention on the need for reliable information on the races of the world and many of the controversies of the period had particular relevance to India, viewed by many researchers as the

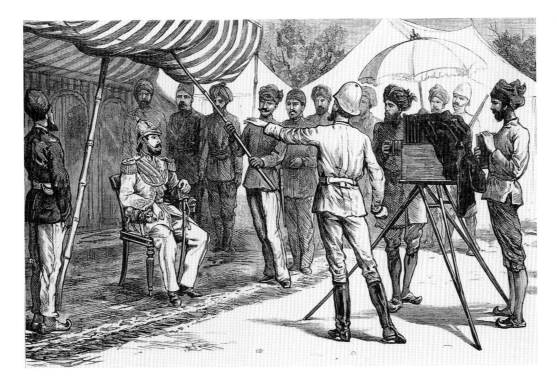

cradle of mankind. The comparative linguistic analysis of race, previously one of the main avenues of enquiry, was greatly displaced in these decades by an increasing emphasis on the physical comparison of racial diversity, so much so that by 1865 it was recognised that 'the appearance, which can so well be preserved and conveyed by photographs'[56] was becoming one of the prime avenues of ethnological investigation.

The application and development of such theories in India is perhaps most clearly seen in the publishing history of *The People of India*, a monumental eight-volume work published between 1868 and 1875 and containing nearly five hundred albumen print copy photographs, pasted in with detailed descriptions of the subjects largely written by Captain P. Meadows Taylor. In a memorandum urging the publication of this work in 1863, John William Kaye had written of the value of such photographic publications, as being able to 'furnish a permanent and more extensively available record of a most interesting and effective effort on the part of the Indian Government to extend our knowledge of our fellow subjects in the east – bringing us so to speak face to face with them.'[57]

The preface to the work states that it was originally inspired by the amateur photographic interests of Lord and Lady Canning, who wished to make a collection of 'photographic illustrations which might recall to their memories the peculiarities of Indian life...Officers of the Indian services, who had made themselves acquainted with the principles and practice of photography, cncouraged

John Murray (attrib.),
Clarence Comyn Taylor, 1861.
As well as his contribution
to *The People of India*, Taylor
took in the early 1860s
what are probably the
earliest survivng photo-
graphs of Nepal. Albumen
print, British Library OIOC
Photo 835 (385)

and patronised by the Governor-General, went forth, and traversed the land in search of interesting subjects.'[58] The number of photographs obtained soon exceeded the demands of a private collection, 'but Lord Canning felt that its importance was sufficient to warrant official sanction and develop-ment' and the collection eventually took the form of a published work. Using prints made from copy negatives, and produced under the editorship of John Forbes Watson and John William Kaye of the India Museum in London, the completed volumes featured the work of some of the most distinguished amateur photographers working in India at the time. The majority of the contributors to the volumes were, apart from a few commercial photographers, generally officers in the civil or military employment of the government and this in itself indicates some of the assumptions implicit in the creation of such a work. Among those named as supplying photographs Willoughby Wallace Hooper, Shepherd and Robertson, Benjamin Simpson, H.C.B. Tanner, C.C. Taylor and James Waterhouse are the most prominent.

To the British in India the fullness of such ethnographical compilations had a clearly political as well as scientific purpose, and the editors' preface outlining the genesis of the volumes was a hugely oversimplified account of a project which for the most part took place after Canning's death in 1862. While the Governor-General and his wife certainly endorsed the collec-tion of such material and may have initiated it, the project really dates from the circular issued to provincial administrations in 1861, soliciting photographs and information on racial types which were eventually to be sent to the London Exhibition of 1862.[59] In order to gather this material at short notice, a number of officers were seconded to photographic duties for periods of up to a year.

Dr Simpson was granted several periods of leave to visit and photograph the hill tribes of north-eastern India, and these portraits were among the eighty photographs which secured him a gold medal at the London International Exhibition in 1862. In Central India Willoughby Wallace Hooper of the Madras Cavalry was released from his usual duties to photograph the tribespeople of Central India, as was James Waterhouse, who between December 1861 and December 1862 travelled around present day Madhya Pradesh photographing groups and individuals. Waterhouse's detailed narra-tive of his travels supplies a fascinating account of the peculiar difficulties to which the Indian photographer in the field was subject.[60] In addition to often uncooperative or uncomprehending subjects, who did not appreciate the necessity to remain still for the duration of the exposure, Waterhouse had to contend with temperatures which, besides being personally debilitating, dried his collodion plates before he could use them and often cracked his negatives if he tried to print

from them in the fierce Indian sun: at Mandleshwar in late May, for instance, the thermometer in his darkroom registered 92 degrees Fahrenheit at seven o'clock in the morning. During this trip Waterhouse estimated that on average he had four failures for every successful photograph and not uncommonly re-took a portrait up to nine times before getting a satisfactory negative. Chemical supplies were irregular, while the rigours of rough travelling damaged his camera.[61] Only at Bhopal, where he remained for most of November, did he achieve wholly satisfactory results, being received by the Begum with great enthusiasm. Intensely pro-British, she entered fully into the spirit of the photographic sessions:

> I used to go up every morning [to the palace] at 6 a.m. and return at 11 or 12, and was taking pictures all the time. I was very successful, indeed, and took nearly 40 negatives without a failure. The Begum dressed herself, her daughter, and Madame Doolan [a Christian member of the Begum's household] in all the fashions of native costume in order that I might get photographs of the dress of native ladies. At Bhopal I was received with more civility than at any other place I visited, except, perhaps, See-tamhow [Sitamau]. I printed a great many prints during my stay at Bhopal, as I was in perfect quiet, alone, and uninterrupted.[62]

Unknown photographer,
*James Waterhouse,
Addiscombe*, 1859.
Albumen print,
British Library OIOC
Photo 42 (75)

Although only a small proportion of the material collected in this way arrived in time for display, it set in train a much more extensive official attempt to gather photographs and data in the following years, an attempt firmly rooted in a sense of a secret and unknown India, ignorance of which had played a part in the upsurge of violent rebellion in the previous decade. Knowledge was an aspect of control and the preface of *The People of India* hinted at the need for better understanding and therefore better government of the population after the upheavals of 1857. Indeed, the letterpress accompanying the photographs tended to describe and emphasize such factors as political reliability or social docility as much as physical attributes. John Forbes Watson, in a paper advocating the systematic compilation of information about India, also saw the collection of ethnographical illustrations as a complementary activity to the Archaeological Survey, and again emphasised both its importance as a means of gaining a 'moral hold' on the population and the speed with which this work must be carried out, for, he pointed out, 'no time should be lost in securing the traces of many tribes now fast disappearing or losing their distinctive characteristics. This applies

mainly to the aboriginal part of the population, to whom roads and railways and the extension of a regular Government now makes access possible.'[63] Thus, for many nineteenth-century theorists and researchers, the importance of the study of ethnology and the creation of photographic records rested both on its 'true political value' and its 'eventual humanitarian influences'.[64]

This purportedly rigorously 'scientific' application of photography to ethnographical research is perhaps most fully illustrated in the work of Maurice Vidal Portman (1860–1935), an administrator in the Andaman Islands in the closing decade of the century. Inhabited as they were by natives who had had little contact with either Europeans or the mainland, the Andaman Islands seemed an ideal laboratory to study man in what was then considered his most 'savage' state. European contacts increased with the building of a penal settlement to accommodate those sentenced after the Indian Mutiny and from the 1860s onwards parties of Andaman Islanders were often brought across to Calcutta to be shown the sights, paraded at meetings of the Asiatic Society and photographed for the benefit of science. Thus the necessarily conflicting aims of the scientist and the administrator – the one looking for man untainted by European contact, the latter attempting to incorporate him into the colonial state as swiftly as possible – were resolved as far as was possible by the photographer, recording life and customs before they were irrevocably altered. In 1890 Portman continued in this tradition by offering to make for the British Museum 'a series of photographs of the Andaman aborigines, in their different occupations and modes of life...so clearly, that with the assistance of the finished articles now in the British Museum, it would be possible for a European workman to imitate the mode of work'.[65] Portman himself showed a sorrowful awareness of the fact that such a photographic record was necessary because of the destructive results of European colonisation – 'the air of the outside world' which shattered the fragile cultural equilibrium of the islands. Resigned to the eventual disappearance of a unique race, photography functioned as both scientific record and memorial.

Samuel Bourne in Search of the Picturesque

If officially sponsored photography in the fields of architecture and ethnology had created an extensive archive of visual information about the subcontinent, the steadily growing dominance of commercial photography from the 1860s onwards saw a loss of that freshness of vision which, married to the wonderful expressiveness and subtlety of calotype photography, had produced such powerful work for a few short years.[66] In a few cases, however, technical skill and artistic vision, combined with a vigorous commercial energy, combined to produce work of comparable stature. Such qualities characterise the work of the former Nottingham bank clerk Samuel Bourne (1834–1912), whose

well-documented career in India laid the foundations of a not inconsiderable commercial fortune.

Bourne, who had taken up photography in about 1854, had by the end of the decade established himself as an amateur photographer of note with a passion for the landscapes of Britain's wilder country, 'the stupendous and lofty mountains, the rugged and romantic passes, the lovely and picturesque valleys', as he characterised their attractions to members of the Nottingham Photographic Society in 1860.[67] Less than three years after making this affirmation Bourne abandoned his banking position in favour of a photographic career in India, a scene of operations combining the natural beauties of the landscape with an expanding commercial potential. On his arrival in 1863, Bourne was pleasantly surprised at the flourishing state of photography, which at the Madras School of Arts resulted in work comparable to that of many English professional studios. Calcutta was no less active, and while the city itself was something of a disappointment, being 'totally devoid of architectural beauty, and its immediate neighbourhood of pictorial interest', he found that 'the professional photographers...appear to be doing a good stroke of business...and the amazing wealth of the place enables artists to realise good prices.'[68]

Alfred Cox & Co., *Samuel Bourne, Nottingham ca.* 1880s. Albumen print, British Library OIOC Photo 1066 (17)

But Bourne did not remain long in Calcutta, before starting on the long journey up to the hill station of Simla, where by March 1863 he had formed a partnership with two already established photographers, Howard (probably the William Howard previously active as a photographer in Calcutta) and Charles Shepherd, formerly of the firm of Shepherd and Robertson. Howard soon left, but Bourne & Shepherd were in the space of a few years to become the most successful firm in the subcontinent, opening additional studios in Calcutta (1867) and Bombay (1870). Bourne himself left India in 1870, and was succeeded by Colin Murray (1840–1884), an equally skilled landscape and architectural photographer, who managed the business until his death from cholera in 1884. The business remains in existence, if in greatly attenuated form, up to the present day, thus making it one of the longest surviving studios in the world.[69]

The success of Bourne & Shepherd was not only a product of the technical skill and commercial acumen of its founders, but relied also on their ability to present a vision of India that coincided with and reinforced European notions of the 'exotic' East – a pageant of dramatic landscapes, noble monuments and romantic ruins, peopled by a wealth of races from untamed tribes on the northern frontiers to immensely wealthy princely rulers. In Bourne's own case an impregnable belief in the civilising power of British rule also directed his

John Falconer, *Bourne & Shepherd Studio, Calcutta,* 1996.

camera towards those subjects which emphasised the morally uplifting and educative role of photography. Thus, while the Mughal architecture of Delhi deserved photographing for its architectural merits, other subjects, such as the Kashmir Gate and the Fort ('where so many of our brave countrymen perished' during the Mutiny) demanded to be recorded as moral and historical lessons. Bourne's belief in photography as an example of European technological superiority and as a weapon in the colonial arsenal is most vividly encapsulated in his pronouncement, with its conflation of the artistic and the militaristic, that the camera, 'with its mysterious chamber and mouth of brass, taught the natives of this country that their conquerors were inventors of other instruments besides the formidable guns of their artillery, which, though as suspicious perhaps in appearance, achieved their object with less noise and smoke.'

In the course of three major photographic expeditions – from Simla to the lower reaches of the Himalayas in 1863, to Kashmir in 1864 and an ambitious six-month journey to the source of the Ganges at the Gangotri Glacier in 1866 – Bourne produced a collection of landscape views unsurpassed in technical skill and compositional elegance. But the beauty of these images was often achieved in spite of the photographer's response to the landscape, which in the higher reaches of the Himalayas was one of uneasy awe at Nature's wanton prodigality. Most of Bourne's photographs were planned, theoretically at least, according to a rigid conception of the correct components of the 'picturesque', elements which included a stretch of water, satisfyingly placed foliage and, ideally, a rustic bridge or other evidence of a human presence. For Bourne (although he later modified these views) India would never produce such good landscape photographs as England, simply 'because the scenery is not so beautiful or so well adapted for the camera.'[70] India seen through the eyes of England seemed untamed, and in Bourne's photographic writing we are made aware of a constant struggle to manage, organise and bring order to a landscape – and a country – that seems altogether too massive and unruly to be contained within the borders of the camera's ground glass screen. It is tempting to interpret Bourne's unease with the threatening immensity of India, and the consequent need to order it within a rigid compositional framework of trees, water and human figures for scale, as an implicit and telling image of a wider desire to reinforce imperial control of the subcontinent.

Samuel Bourne himself remained in India for only seven years, but by the end of the decade the Bourne & Shepherd catalogue contained some two thousand views from all over the subcontinent.

While it was his Himalayan scenes that most strongly gripped the imaginations of both his contemporaries and posterity, this work formed only a relatively small portion of the firm's output. The colonial architecture and topography of Indian cities, particularly Calcutta, was thoroughly documented, as well as indigenous glories – the forts and palaces of Rajasthan, the Moghul glories of northern India and the great Hindu temple architecture of the south. The comprehensive nature of this documentation inevitably inspires comparison with the picturesque tours of the late eighteenth-century artists like the Daniells. More importantly, it was to form the model to which the succeeding generations of commercial photographers aspired, defining a range of subject matter and a compositional approach which was assiduously imitated by numerous lesser photographers. The firm's influence in this respect is difficult to over-estimate. One has only to compare the work of John Edward Saché, himself a photographer of considerable skill who arrived in India shortly after Bourne and operated studios in Calcutta, Mussoorie and Naini Tal in the succeeding decade. Much of Saché's work extends well beyond the boundaries of flattery and enters the realm of plagiarism in the precision with which

Bourne & Shepherd, *Colin Murray, Calcutta, ca. 1880*. After Samuel Bourne's departure from India in 1870, Murray became the firm's main landscape and architectural photographer. Albumen print, British Library OIOC Photo 1066 (2)

a number of his views imitate Bourne's photographs. From lesser photographers, such imitation produced flat and uninteresting work, but in the hands of the more accomplished photographers both Indian and European who followed in his footsteps between the 1860s and 1900s and produced such an astonishingly detailed documentation of Indian life and landscape, his example remained an inspiration.

The Indian Photographer

The story of photography in nineteenth-century India has inevitably been dominated by Europeans: as an invention of European technology introduced into India, it was used by Europeans to produce a picture of the subcontinent pleasing to their preconceptions. Surviving collections and records have also tended to emphasise the European contribution at the expense of the Indian. Apart from the few internationally known figures like Lala Deen Dayal, Indian photographers have as yet received comparatively little attention: the at present largely secret history of *Indian* photography will no doubt emerge more fully in time, as researchers in the subcontinent start to investigate

vernacular sources of information in more detail. As yet only the outlines of the story can be sketched in. And while such information is often tantalisingly vague, it does at least indicate that from almost the earliest days, there were a number of talented practitioners, both amateur and professional, who made significant contributions to the growth and spread of the medium and who have not so far been adequately recognised.[71]

Evidence of the extent of early Indian involvement in photography is most clearly seen in the amateur societies, where Indian members were active in all three Presidencies. In Calcutta, the celebrated scholar, antiquarian and active amateur photographer Rajendralal Mitra was appointed Treasurer to the Photographic Society of Bengal in 1857, one of a number of Bengalis who made an active contribution to the Society. Among them was Babu Preonath Sett, Treasurer to the Society, who with the President 'hoped...to commence the tuition of some native lads in the processes of photography'.[72] This positive start soon received a setback, however, when Rajendralal Mitra was expelled from the society for becoming involved in a political controversy relating to the maltreatment of Indian indigo workers in Bengal. Although he received some support from European quarters after speaking out publicly against the behaviour of the estate owners,[73] the damage had been done and after his expulsion most of the Indian members henceforward boycotted the society.

In Bombay, where the first photographic society in India had been formed in 1854, a happier situation prevailed. Here too, several distinguished Indians whose interests extended to photography were among the founder members. The scholar Dr Bhau Dajee was actively involved in the society's work, as was the inventor and engineer Ardaseer Cursetjee.[74] But it was Bhau Dajee's brother Dr Narain Dajee who made perhaps the most important contribution. In addition to the thirty-one portraits shown at the 1857 exhibition of the Photographic Society of Bengal and mentioned earlier, he was also a tireless contributor to the Bombay society's own exhibitions and from the mid-1850s to the 1860s practised as a professional photographer in addition to his medical duties. Narain Dajee's work was of sufficiently high quality for him to have applied for the post of Instructor in Photography at the Elphinstone Institute when classes were started there in 1855, although in the event the position was awarded to William H.S. Crawford, a professional photographer of longer experience.[75]

Such classes were probably one of the few sources of expert tuition in the first decades of photography in India, and during their generally short existences taught a number of Indians the theory and practice of photography. In Bombay, one of the most noteworthy pupils was Hurrichund Chintamon, who in 1855 won the annual prize for the best picture and who had thereafter a long career as a commercial photographer lasting into the early 1880s. A large collection of his views was selected for display at the Paris International Exhibition of 1867 and he was also one of the photographic society's most active members. The Bombay classes offered tuition in a variety of photo-

graphic procedures, including 'daguerreotype, wax paper, talbotype and albumenized paper processes',[76] and were intended to supply a thorough grounding in all aspects of the medium, both theoretical and practical. But although attendance was at first good and work was produced that 'would do credit to most European Amateur Photographers,' sickness and falling numbers eventually brought about the closure of the classes.[77]

In 1856, Dr Alexander Hunter of the Madras School of Industrial Arts, was also petitioning government for a similar class to be set up in his own institution. The request for a permanent photographer was turned down by the Madras Government on the grounds of lack of demand and the argument that the subject did not merit a full-time course since 'a very few weeks will suffice to teach all that can be learned from an instructor'.[78] It was conceded, however, that Captain Linnaeus Tripe, the newly appointed Presidency photographer, should spend a few months of each year giving tuition in the subject in Madras. One photographer trained at the school, was C. Iyahsawmy, who in addition to working as Tripe's assistant, had a reputation as an accomplished photographer in his own right. By 1860, he had been appointed photographer at the Madras School of Arts and was one of the largest contributors to the Photographic Society's exhibition in that year. The school in fact continued to train photographers after the abolition of Tripe's post and despatched a number of photographers to record the antiquities of Southern India in succeeding years, including the anonymous Indian photographer who took the photographs used to illustrate James Wilkinson Breeks' *An account of the primitive tribes and monuments of the Nilagiris*, published by the India Museum in London in 1873.

Not all such photographic activity was found in official institutions and the Reverend Henry Polehampton gives an interesting sketch of the work of the Indian photographer at Lucknow, Ahmud Ali Khan, in the days just before the Indian Mutiny. Two albums of portrait work by this photographer survive, and while the technical quality of the photography is less than perfect, the prints form a unique record of the inhabitants of the city, both Indian and European, at a crucial point in its history. Polehampton made several visits to Ahmud Ali Khan and describes him as 'a very gentlemanly man, a Mahommedan, and most liberal. He won't take anything for his likenesses. He gives you freely as many as you want, and takes no end of trouble. I have no doubt his chemicals, &c. must cost him more than £100 per annum, at the least'.[79] Lucknow was later also the base for another Indian photographer, the municipal engineer Darogha Abbas Ali, who was the author of *The Lucknow album* (Calcutta, 1874), a guide to the city containing fifty of his own photographs, as well as *An illustrated historical album of the Rajas and Taaluqdars of Oudh* (Allahabad, 1880).

For many of the ruling families, photography became something of a fashionable pursuit. Samuel Bourne records that the Raja of Chamba owned an expensive set of cameras, but was rather more interested in displaying them to visitors than in taking pictures.[80] But several rulers were

accomplished photographers, including Ram Singh, the Maharaja of Jaipur[81] and various members of the ruling family of Tripura, who had taken up photography in its early days. Several ruling families, if they did not have the inclination to learn photography themselves, patronised the medium by employing state photographers. The Maharaja of Benares, for instance, employed Brajo Gopal Bromochary in this capacity from the late 1860s. And in Jodhpur, official authority led to the inclusion of a large and important series of prints by an anonymous Indian photographer or photographers in one of the volumes of the census report.[82]

Of all Indian photographers, only Lala Deen Dayal has secured international attention on a scale comparable to Samuel Bourne, and in many ways their achievements reflect each other's: the establishment of several successful and fashionable studios, patronage from the highest quarters of society and the creation of a large body of surviving work produced to the highest technical standards. Born in 1844, Dayal was trained as a draughtsman at the Thomason Civil Engineering College at Roorkee and took up photography in the 1870s[83]. One of the keys to his success was the ready acceptance his work found in European circles, and this appreciation led to his appointment as architectural photographer accompanying Sir Lepel Griffin's Central India tour of 1882, during which he produced a magnificent collection of views of Gwalior, Khajuraho, Sanchi and other sites.[84] The patronage of the Nizam of Hyderabad was a further assurance of success, and by the turn of the century, his firm had a stock of views and portraits as extensive as any in India. In many ways Deen Dayal presents a more varied record of Indian life than any European firm was able to do, since he seems to have moved with ease between several worlds – from the recording of Viceroy's tour and official durbars to more informal and sympathetic studies of Indian life.

Unknown photographer, *Lala Deen Dayal, ca. 1900*. Modern copy print, British Library OIOC Photo 618 (1)

By the end of the century entries in commercial directories indicate that Indian photographic firms were as firmly established as European, and a publication of this period confirms the popularity of photography. H.M. Ibrahim's Urdu work *Rahno-ma-i-Photography-ya-usil-i-musawery* or *A guide to photography or the rules for taking photographs*, was favourably reviewed on its appearance in 1899 by *The Journal of the Photographic Society of India*. The society's reviewer praised 'the most exhaustive nature' of the book, and its publication testifies to a growing interest in photography among Indians at both amateur and commercial levels, an interest confirmed by the writer, who 'says that every year increasing numbers of the more advanced natives of this country...are anxious to learn the art of photography, either as a profession, or for their own pleasure and this has induced him to compile a work

which should find a very large circulation.' Despite the fact that only a small proportion of native photographers were listed in contemporary commercial directories, such remarks point to a thriving photographic market serviced by indigenous operators.

Photography had gained its first secure foothold in the Indian subcontinent through the dedication of amateurs who, whether in the course of official duty or through enthusiasm for a cultured and artistic leisure pursuit, had created a substantial and impressive body of work. It was on these foundations that the professional photographer built, producing hundreds of thousands of images of India for a predominantly European market. These ranged from the inspired to the mundane, but for three decades demand for such material maintained the position of the commercial photographer in what was still a difficult and demanding medium. But a further shift took place as technological advances in both cameras and chemistry brought photography within the grasp of almost all and the primacy of the professional was eroded. Samuel Bourne, soon after his return from India in 1870, had foreseen this development and bemoaned the abandonment of high-quality, large-format work in favour of smaller and more convenient equipment which produced 'small scraps fit only for the scrapbook'.[85] Photographic manuals specifically aimed at the amateur in India had started to appear by 1860,[86] and intermittently thereafter;[87] but the appearance in the mid-1890s of George Ewing's comprehensive amateur manual which ran into several editions[88] signals the ending of an age of photographic experiment and achievement.

NOTES

(Primary reference sources cited with the prefix 'IOR' refer to the India Office Records, housed in the Oriental and India Office Collections, British Library, London.)

1 Rev. Joseph Mullens, *On the applications of photography in India* (Journal of the Photographic Society of Bengal, no. 2, 21 January 1857, pp. 33–38), p. 33.

2 *Idem.*

3 James Burgess, *Photographs of architecture and scenery in Gujarat and Rajputana* (Bourne and Shepherd, 1874). The volume contains 30 architectural and topographical views by Colin Murray, who was responsible for much of the firm's landscape work after Samuel Bourne's return to England.

4 Amateur photographic societies were formed in Bombay in 1854 and in Bengal and Madras in 1856.

5 For a brief account of the major technical process in use during the period under discussion, see pp. 143–44.

6 *The Bombay Times*, 14, 18, 21 December 1839.

7 By early 1840, for instance, the *Friend of India* was advertising imported daguerreotype equipment, and around this time a lithograph, copied from a daguerreotype, was produced of the Sans Souci Theatre, Calcutta. The original does not appear to have survived, but the lithograph is reproduced in Wilmot Corfield, *Calcutta faces and places in pre-camera days*, (Calcutta, 1910), p.59.

8 *The Calcutta Courier*, 3 October 1839; also reported in *The Englishman* of 4 October 1839 and *The Asiatic Journal*, new series vol. 31, January–April 1840, pp. 14–15. Frustratingly few technical details of O'Shaughessy's experiments are supplied, but in this case the photogenic drawings probably involved using light-sensitive paper to make impressions of objects (such as leaves or lace) without the use of a camera. Although the use of a lens in mentioned in the reports, this appears to have been used to direct light rather than as an image-forming device. I am grateful to Dr Michael Ware for discussions and information relating to the early photographic use of gold compounds.

9 By which time word of his researches had filtered back to Europe: see, for instance the article discussing his work in the *Hannoversche Zeitung* of 28 February 1840.

10 *The Calcutta Courier*, 5 March 1840.

11 Apart from that section of the audience 'who continued conversing in a tolerably loud tone, while the explanation or lecture was going on.' *The Englishman and Military Chronicle*, 4 May 1840.

12 *Journal of the Photographic Society of Bengal*, no. 2, 21 January 1857, p. 26.

13 Joseph Mullens, op. cit., p. 35, recalls Rowe's daguerreotypes of St Paul's Cathedral, Calcutta,

swathed in scaffolding, which would date these now lost images to the early 1840s. In the course of his photographic career Rowe became expert successively in the daguerreotype, the calotype and the wet collodion processes.

14 *The Englishman*, 6 July 1844.

15 *The Bengal and Agra Directory and Annual Register for 1849*, p. 336.

16 *Miscellaneous letters received*, vol. 193, 1856. IOR/E/1/193.

17 *Photography in Madras* (Illustrated Indian Journal of Arts, February 1852), p. 32.

18 The East India Company purchase, which apparently represents a complete set of views, contains 259 prints of Calcutta, 61 of Madras, 70 of Ceylon, 41 of Mauritius and 27 of Cape Town. Fiebig's original letter to the Company states that 'the whole set will comprise about 400 views and about 50 groups of natives and single figures.'

19 These wishes were apparently never realised. Apart from the sale to the East India Company, almost no work by Fiebig has come to light and nothing is known of his life after 1856.

20 John McCosh, *Advice to officers in India* (London, 1856), p.7.

21 *Journal of the Photographic Society of Bombay*, no. 1, January 1855, pp. 2–3.

22 Photography was taught at the East India Company's college at Addiscombe from 1855 by the drawing master Aaron Penley. H.M. Vibart, *Addiscombe, its heroes and men of note* (London, 1894), p.212.

23 His work was also made known in Europe by the London publisher J. Hogarth, who issued thirty of these large views in a portfolio entitled *Agra and its vicinity* (London, 1858); a second set of views, in a different format appeared in J.T. Boileau, *Picturesque views in the N.W. Provinces of India* (London, 1859).

24 And, in the case of one photographer at least, had a more fatal impact: the daguerreotypist J.W. Newland was an early casualty of the uprising, *The Bengal Hurkaru and India Gazette* (26 May 1857) reporting that he was killed while travelling between Delhi and Meerut, 'taken from the dak carriages and mutilated with great barbarity'.

25 For a fuller account of Beato's work in India, see David Harris, *Topography and memory: Felice Beato's photographs of India, 1858–1859* in Vidya Dehejia (ed), *India through the lens. Photography 1840–1911* (Washington, 2000), pp. 119–31.

26 John Fraser, *Beato's photograph of the interior of the Sikandarbagh at Lucknow* (Journal of the Army Historical Research, vol 64, no. 237, 1981), pp. 51–55.

27 *The Journal of the Photographic Society*, vol 5, no. 79, 1859, p. 185.

28 From the evidence of the prints, it seems likely that Tytler accompanied Beato on photographic excursions in Delhi: several of his views are almost identical in composition to Beato's.

29 *The Englishman*, 28 May 1859.

30 *Idem.*

31 Gaston Tissandier (ed. John Thomson), *A history and handbook of photography* (2nd edition, London, 1878), pp. 318–19.

32 Public Despatches to Bengal, no. 1 of 1847, 27 January 1847, IOR/L/P&J/3/1021.

33 Proceedings of Financial Department of the Government of India, 4th April 1851, Board's Collections, V.3687, IOR/F/4/2503.

34 Public Despatches to Bengal, no. 1 of 1847, 27 January 1847, IOR/L/P&J/3/1021.

35 Bombay Public Despatches, 29 December 1854, IOR/E/4/1101 ff.1449–51. Whether Biggs himself was responsible for first suggesting the use of photography to the Company is unclear. Over two decades later, in a letter to the Secretary of State for India dated 3 December 1877, he writes that it was his presentation of 'a large manuscript volume of copies of sculptures' to the Court of Directors in 1853, 'which mainly led to the desire on the part of the government to have the sculptures and inscriptions copied systematically' (Geographical Home Correspondence, IOR/L/E/2/103 item 50). The whereabouts and contents of this volume have not been discovered.

36 Bombay Public Despatches, 18 February 1857, IOR/E/4/1107 f. 452.

37 Thomas Biggs, Theodore C. Hope and James Fergusson, *Architecture at Ahmadabad, the capital of Gujarat*; P.D. Hart, A. Cumming, T. Biggs, Major Loch, Meadows Taylor and James Fergusson, *Architecture at Bijapur, an ancient Mahomedan capital in the Bombay Presidency*; W.H. Pigou, A.C.B. Neill, T. Biggs, Meadows Taylor and James Fergusson, *Architecture in Dharwar and Mysore*. All published by John Murray, London, 1866. The Ahmadabad volume, a less lavish production than the other two volumes, contains photographs taken by Biggs in the 1860s rather than the 1850s. These publications were intended to be the start of a continuing series of works to be brought out under the guidance of the Committee of Architectural Antiquities of Western India, but in the event no further volumes appeared.

38 Fort St George Public Consultations, 11 March 1865. Board's Collections, IOR/F/4/2725, no. 198064.

39 The volumes were published as follows: *Photographic views of Madura*; *Photographic views of Poodoocottah*; *Photographic views of Ryakotta and other places in the Salem district*; *Photographic views of Seringham*; *Photographic views in Tanjore and Trivady*; *Photographic views of Trichinopoly*. All published in Madras in 1858.

40 Tripe to Chief Secretary, Madras Government, 1 September 1856. Board's Collections, IOR/F/4/2725 no. 198065.

41 Fort St George Public Consultations, 15 April 1859, IOR/P/249/69.

42 James Fergusson, *History of Indian and eastern architecture* (London, 1876), preface.

43 James Fergusson, *Illustrations of various styles of Indian architecture* (London, 1869), p. 6.

44 *Ibid*, p. 10.

45 Report by Thomas Biggs on photographic tour, dated 4 January 1856, Board's Collections, IOR/F/4/2665.

46 Text by Boswell in Linnaeus Tripe, *Photographic views of Ryakotta and other places, in the Salem district* (Madras, 1858), plate 5.

47 *Ibid*, plate 8.

48 Bengal Public Proceedings, no. 61 of September 1867, IOR/P/432/3.

49 Bengal Public Proceedings, no. 9 of July 1868, IOR/P/432/4.

50 This proposal was therefore soon modified and by April 1868 the government was asking H.H. Locke, Principal of the Government School of Art in Calcutta, to investigate whether Rs. 1000 'will be sufficient to induce a professional artist to undertake to make photographs of all the views that might be required in connexion with one set of buildings'. Bengal Public Proceedings, no. 11 of July 1868, IOR/P/432/4.

51 A detailed memorandum outlining this scheme for the documentation of Indian architecture, and the use of photography within it, was published by the India Museum at about this time. See John Forbes Watson, *Report on the illustration of the archaic architecture of India, &c.* (London, 1869).

52 India Office Records, Home Proceedings, Surveys, vol. 1501, 1880.

53 Tripe to F.A. Murray, Secretary to Governor of Madras, 22 July 1856. Board's Collections, IOR/F/4/2725 no. 198065.

54 *Journal of the Photographic Society of Bengal*, no. 3, 20 May 1857, p. 68.

55 The publication ran for 36 monthly issues between 1856–1859, each number containing three original prints with descriptive captions. Johnson and Henderson's contribution, as well topographical and architectural views, was a series of portrait studies entitled *Costumes and characters of Western India*.

56 *Proceedings of the Asiatic Society of Bengal*, August 1865, p. 148.

57 Memorandum from John Forbes Watson to John William Kaye, dated 18 July 1863, discussing plans for the publication of *The People of India*; IOR/L/E/6/37, item 39.

58 Introduction to *The People of India*.

59 Letter to the Secretary of the Government of Bengal,

dated 17 June 1861, Bengal Public Proceedings 1861, IOR/P/15/21.

60 See Government of India Foreign Consultations (General), July 1863, pp. 6–67. IOR/P/205/14.

61 In addition to the rigours of the tour, at its conclusion Waterhouse estimated that in order to get the 1252 prints sent in (20 copies from each of about 60 photographs), poor quality paper and other factors made it necessary to make over 3000 prints. *Ibid*, p. 37.

62 *Ibid*, p. 36.

63 John Forbes Watson, *On the measures required for the efficient working of the Indian Museum and Library, with suggestions for the foundation, in connection with them, of an Indian Institute of Enquiry, Lecture, and Teaching* (London, 1874), p.26.

64 George Gliddon in L.F.A. Maury, F. Pulszky & J.F. Meigs, *Indigenous races of the earth* (Philadelphia, 1857), p.609.

65 *Report on the administration of the Andaman and Nicobar Islands…for 1893–1894* (Calcutta, 1894, pp.115–16), IOR/v/10/610.

66 Changing fashions and developments in technical matters also played their part: paper negatives were being superseded by glass and by the early 1860s the work of photographers like Murray and Tripe, while still earning praise, was being dismissed as 'inferior to what might have been expected of collodion', the latter by 1862 considered superior in terms of 'clearness, sharpness, and artistic effect'(*Journal of the Bengal Photographic Society*, vol 1, no. 1, 1 May 1862, p.6 and no. 2, 1 September 1862, p. 40).

67 Samuel Bourne, *On some of the requisites necessary for the production of a good photograph*, (The Nottingham Athenaeum Society's Magazine, October 1860), pp. 40–41.

68 Samuel Bourne, *Photography in the east* (British Journal of Photography, 1 July 1863), p.269.

69 For the most accurate account of Bourne's Indian career, see Gary D. Sampson, *The success of Samuel Bourne in India*, (History of Photography, Winter 1992, pp.336–47). See also Sampson, *Photographer of the picturesque: Samuel Bourne* in Vidia Dehejia (ed), *India through the lens. Photography 1840–1911* (Washington, 2000), pp. 163–75.

70 Samuel Bourne, *Photography in the east* (British Journal of Photography, 1 September 1863), p.346.

71 Some attempt to analyse the characteristics of a specifically Indian response to photography (conceptually unconvincing and factually unreliable in the view of this writer) is made in Judith Mara Gutman, *Through Indian eyes* (New York, 1982). But see also Christopher Pinney, *Camera Indica. The social life of Indian photographs* (London, 1997).

72 *Journal of the Photographic Society of Bengal*, no.2, 21 January 1857.

73 See the pamphlet, *Address, a member opposing an intended resolution to expel Rajendralala Mitra for speaking against the indigo planters at a public meeting* (Calcutta, 1857),

74 His obituary in the *Proceedings of the Institution of Civil Engineers* (1878) describes him as 'foremost in introducing photography and electro-plating into Bombay'.

75 Correspondence relating to this appointment, and the history of the classes in general, can be found in Board's Collections, IOR/F/4/2677 no. 181526.

76 ibid.

77 In fact the Elphinstone Institute class had never been intended as a permanent fixture, since the authorities felt that a school of photography would in the long run be more appropriately housed in the soon to be opened Sir Jamsetjee Jeejeebhoy School of Art. When this was established the photographer appointed was Narayan Shivshanker, who was responsible for a good deal of architectural photography in the Bombay area in succeeding years.

78 Fort St George Public Consultations, 20 May 1856. In Board's Collections, IOR/F/4/2725 no. 198064

79 E. and T.S. Polehampton (ed.), *A memoir, letters and diary of the Rev. Henry S. Polehampton* (London, 1858), p.212.

80 Samuel Bourne, *Narrative of a photographic trip to Kashmir (Cashmere) and adjacent districts* (British Journal of Photography, 2 November 1866), p.524.

81 Ram Singh also employed a T. Murray as court photographer, and it is unclear how much of the photographic work was produced on his own.

82 Haryal Singh, *Report on the census of 1891. Volume II: The castes of Marwar* (Jodhpur, 1894).

83 He may well have been introduced to the medium at the college, since photography had been taught to Indian students there since 1864, 'to enable them to show the progress of public works' (*Photographic News*, 1864), p.59.

84 These were later reproduced as collotypes in Griffin's *Famous monuments of Central India* (London, 1886).

85 *British Journal of Photography*, 1871, p.425.

86 F. Fisk Williams, *A guide to the Indian photographer* (Calcutta, 1860). An advertisement in the back of this volume refers to a so far untraced but clearly earlier work, Cowley's *Photography in India*.

87 John Blees, *Photography in Hindostan; or reminiscences of a travelling photographer* (Bombay, 1877).

88 George Ewing, *A handbook of photography for amateurs in India* (Calcutta, 1895; second edition, 1909).

THE PLATES

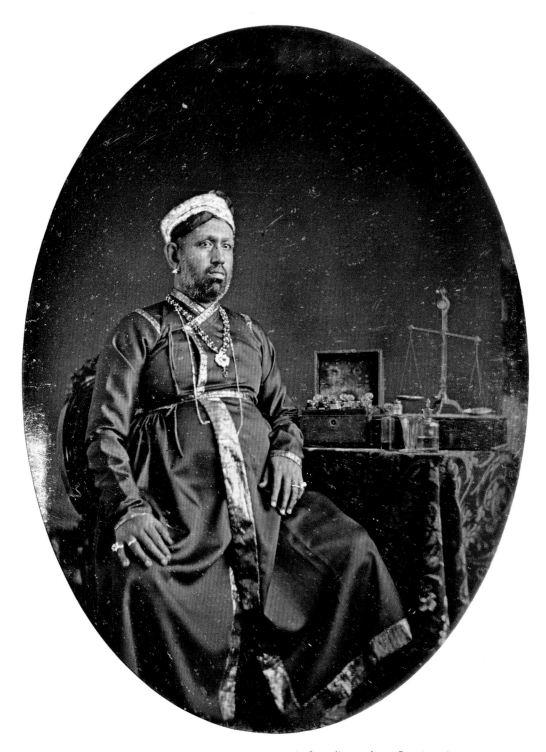

UNKNOWN PHOTOGRAPHER, *Daguerreotype portrait of an Indian merchant, 1850s* (cat. 1)

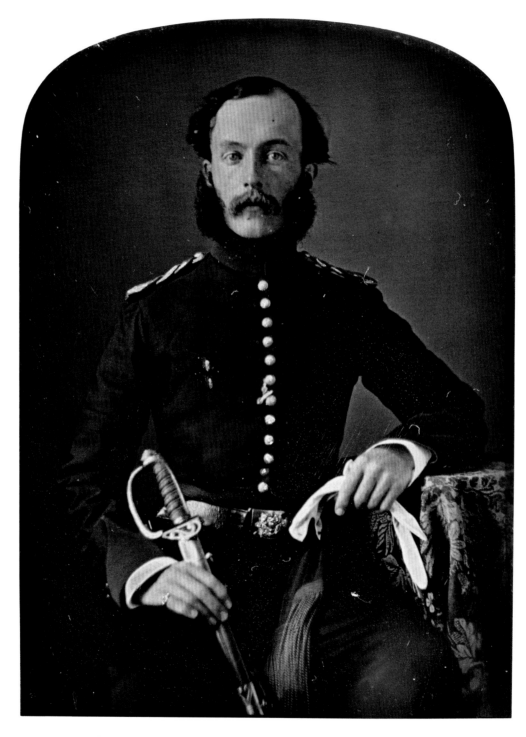

JAMES WILLIAM NEWLAND, *Daguerreotype portrait of an Army Officer*, 1850s (cat. 5)

WILLIAM JOHNSON and WILLIAM HENDERSON, *An Eastern Bishop*, 1857 (cat. 14)

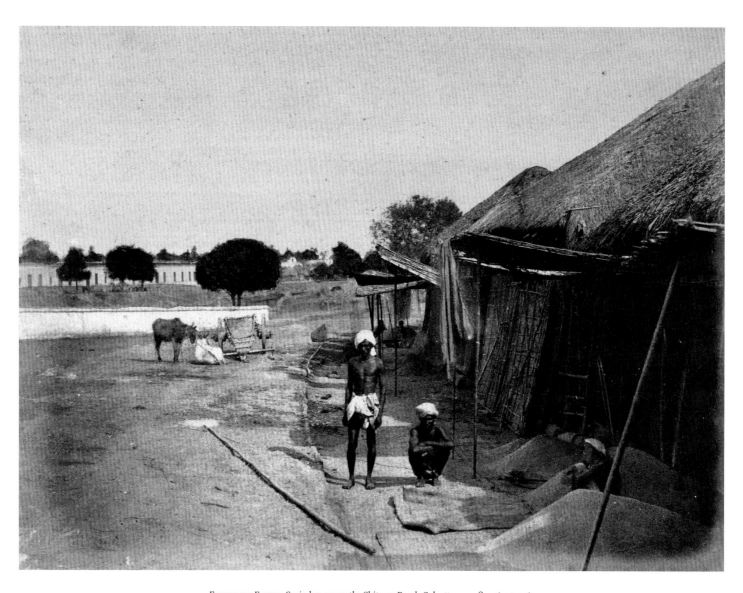

FREDERICK FIEBIG, *Grain bazaar on the Chitpore Road, Calcutta, ca. 1850* (cat. 21)

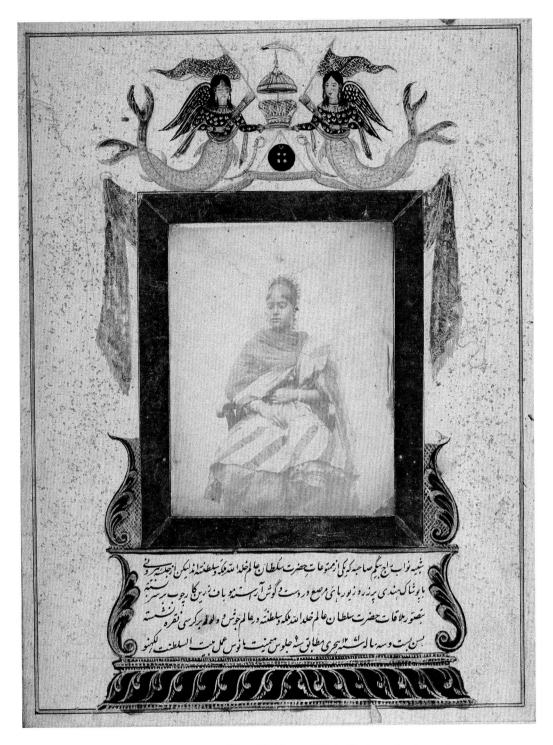

AHMAD ALI KHAN, *Portrait of Nawab Raj Begum Sahibah of Oudh*, ca. 1855 (cat. 22)

Benjamin Simpson, *Portrait of Lord Canning*, 1861 (cat. 23)

JOSIAH ROWE, *Portrait of Lady Canning*, 1861 (cat. 24)

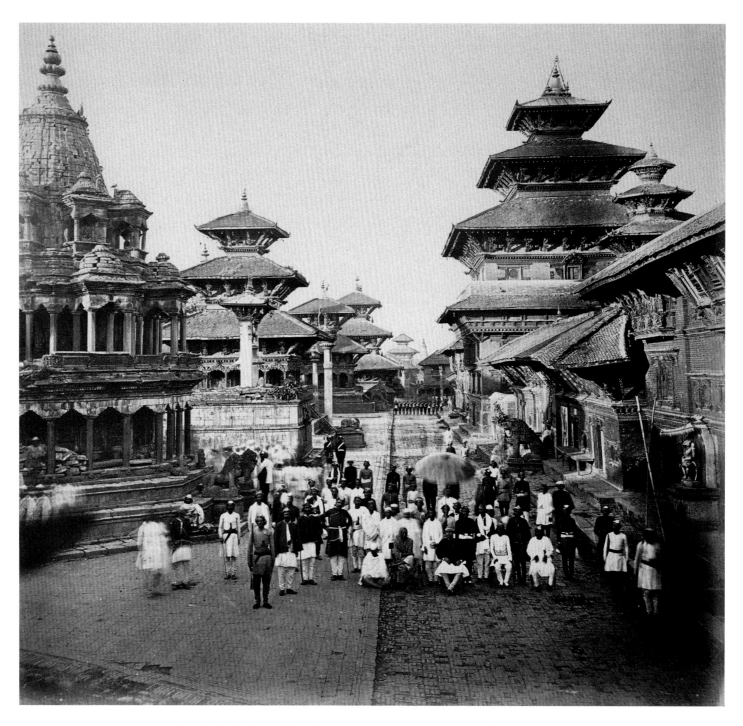

CLARENCE COMYN TAYLOR, *The Durbar Square at Patan, Nepal, from the south*, 1863–1865 (cat. 27)

LINNAEUS TRIPE, *View of the hill fort at Trimium [Tirumayam] from top of gateway of the outer wall*, 1858 (cat. 33)

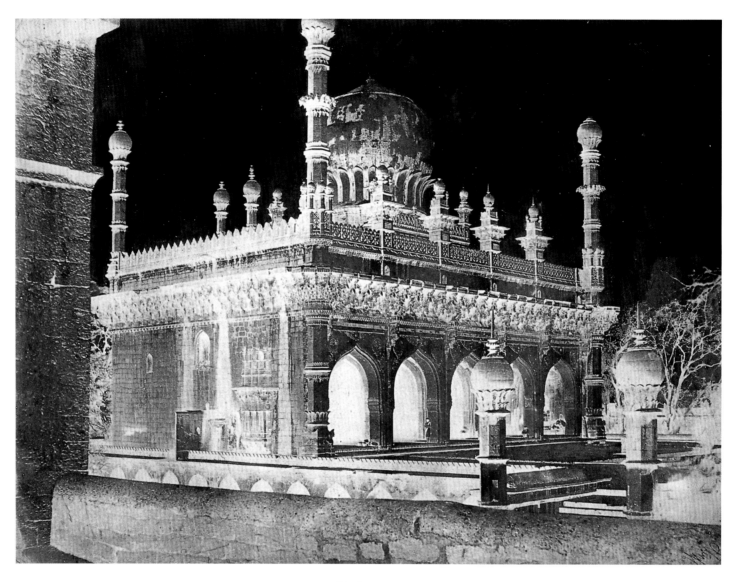

THOMAS BIGGS, *Mosque of Ibrahim Rauza, Bijapur*, 1855 (cat. 29)

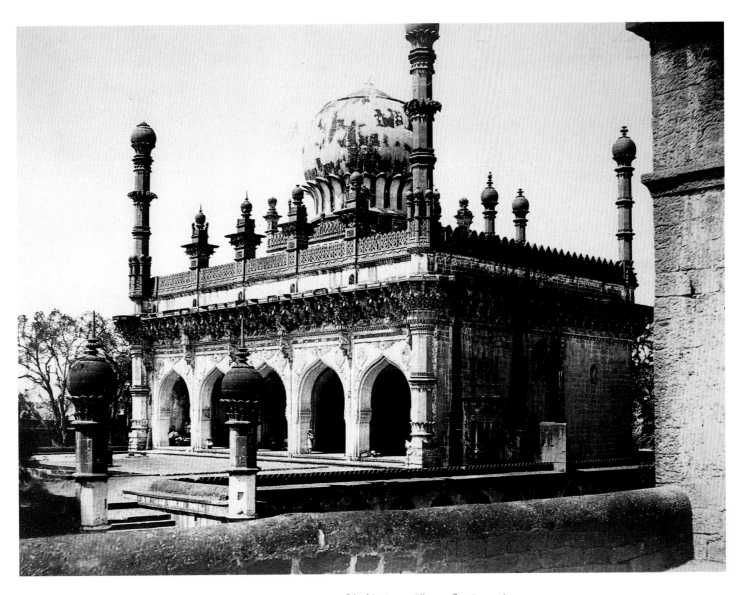

THOMAS BIGGS, *Mosque of Ibrahim Rauza, Bijapur*, 1855 (cat. 30)

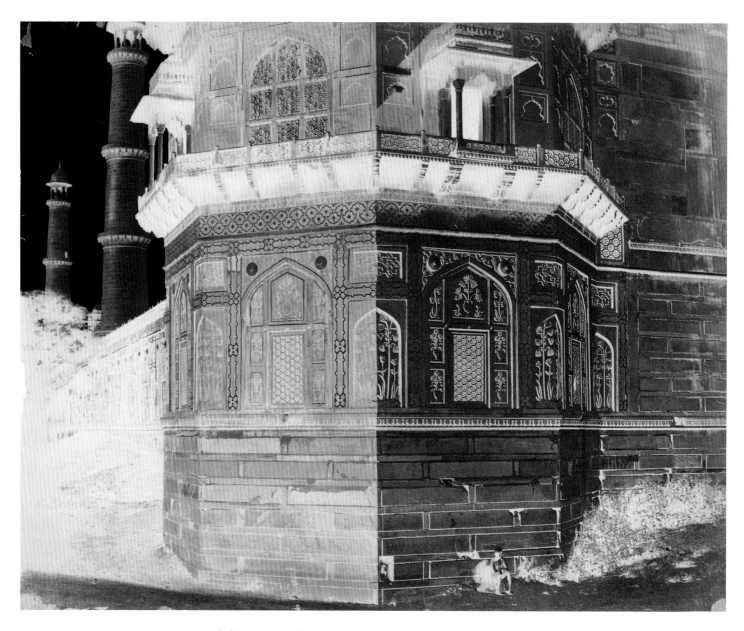

JOHN MURRAY, *Detail of the outer tower of the Jamat Khana in the Taj Mahal enclosure, Agra*, 6 February 1862 (cat. 35)

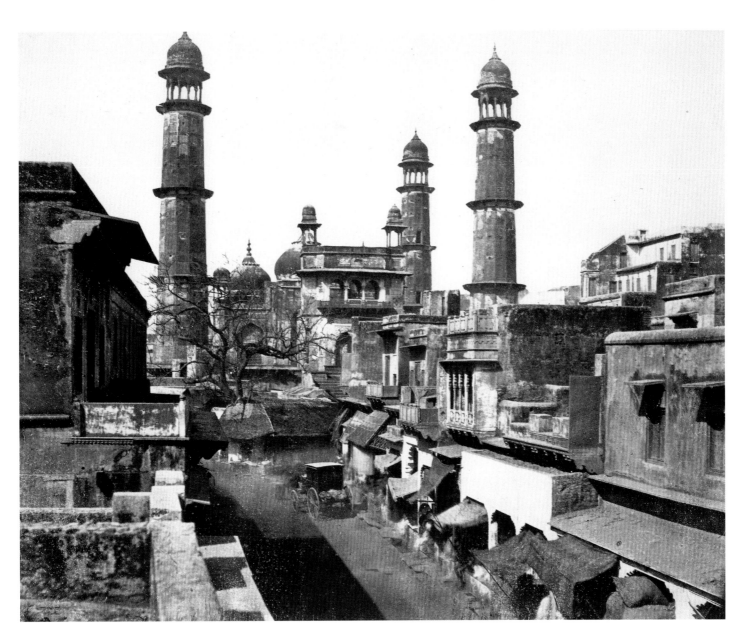

John Murray, *Street scene in Muttra, with the Jami Masjid in the background*, mid-1850s (cat. 37)

Donald Horne Macfarlane (attrib.), *Dutch tombs at Surat, ca.* 1860 (cat. 42)

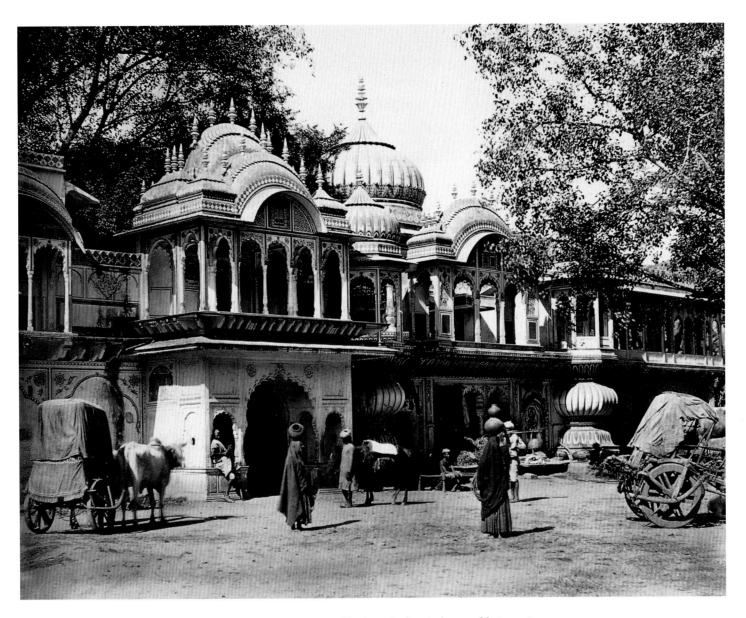

Eugene Clutterbuck Impey, *Chhatri at Rajgarh, Rajasthan*, ca. 1862 (cat. 43)

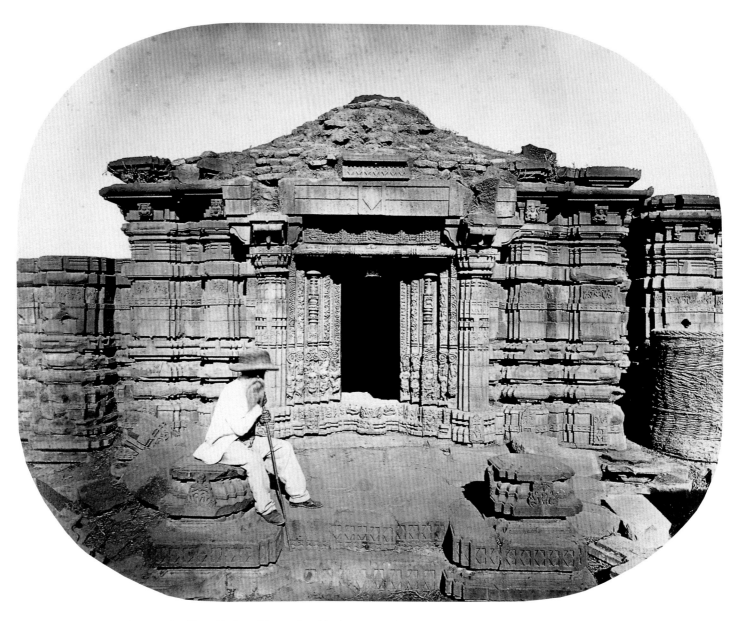

ROBERT GILL, *Captain Gill seated in front of the west face of the Chintamani Mahadeva Temple, Kothali, Buldana District, Berar, 1871 (cat. 45)*

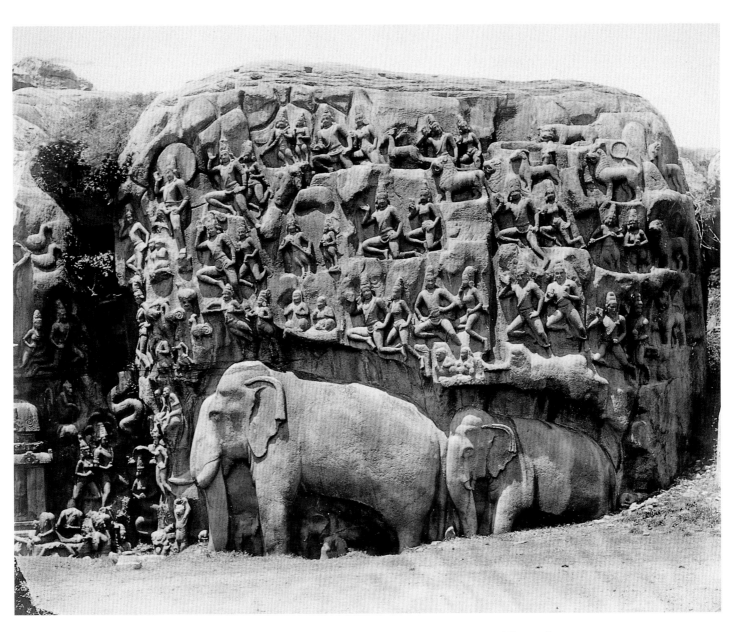

EDMUND DAVID LYON, *Right-hand section of Arjuna's Penance, Mamallapuram, 1868 (cat. 48)*

LALA DEEN DAYAL, *View of the Stupa at Sanchi from the south-west, during repairs,* 1881 (cat. 49)

James Waterhouse, *The Begum of Bhopal and Shah Jehan in costume for a private entertainment,*
Bhopal, 1862 (cat. 59B)

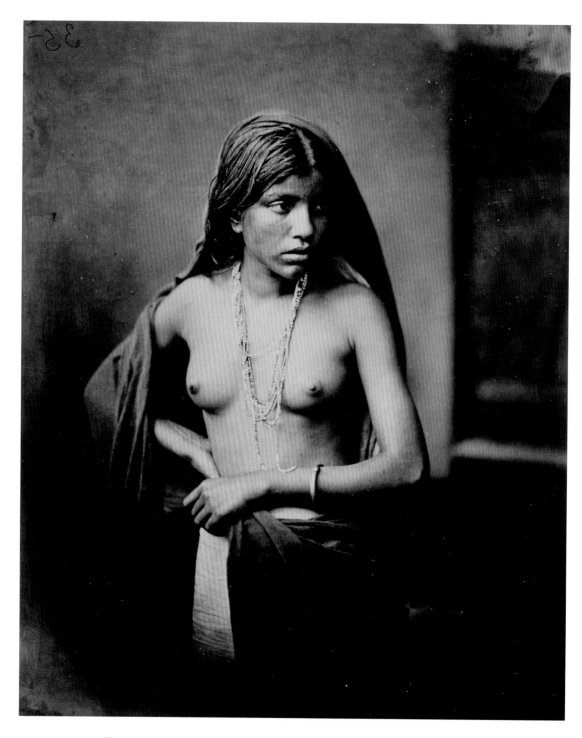

UNKNOWN PHOTOGRAPHER, *Portrait of a young woman, Eastern Bengal, early 1860s* (cat. 54)

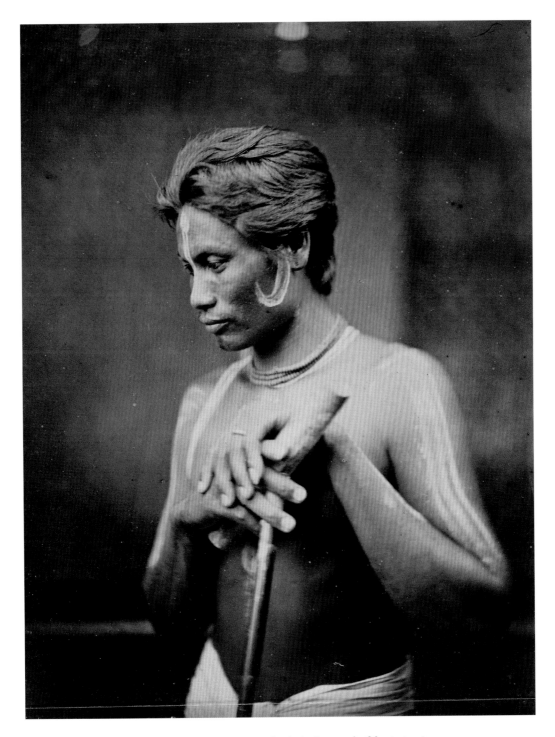

Unknown Photographer, *Manipuri polo player, early 1860s* (cat. 52)

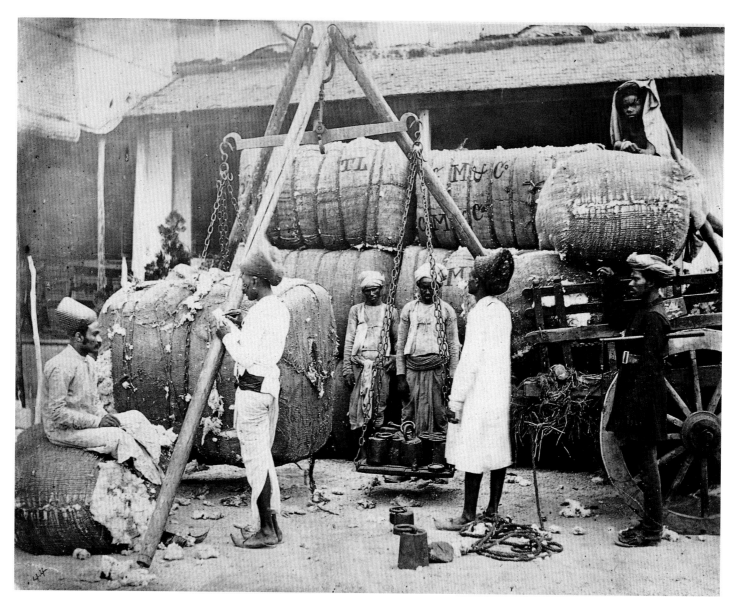

WILLIAM JOHNSON and WILLIAM HENDERSON, *Weighing cotton, Bombay, ca.* 1858 (cat. 58)

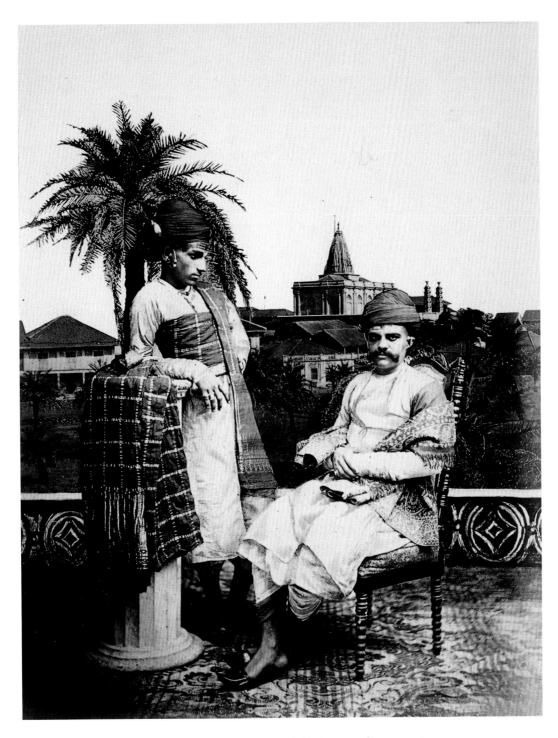

WILLIAM JOHNSON, *Ghur-Baree (Householding) Gosaees*, 1850s (cat. 57)

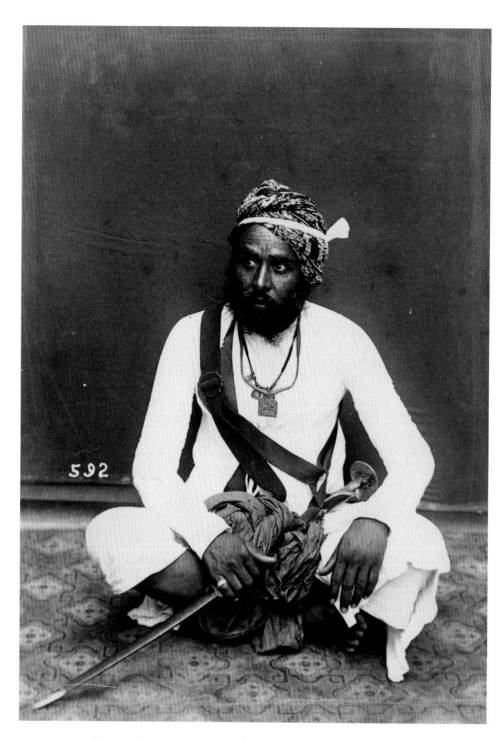

Unknown Indian Photographer, *Charan Rajput, Jodhpur*, ca. 1890 (cat. 63)

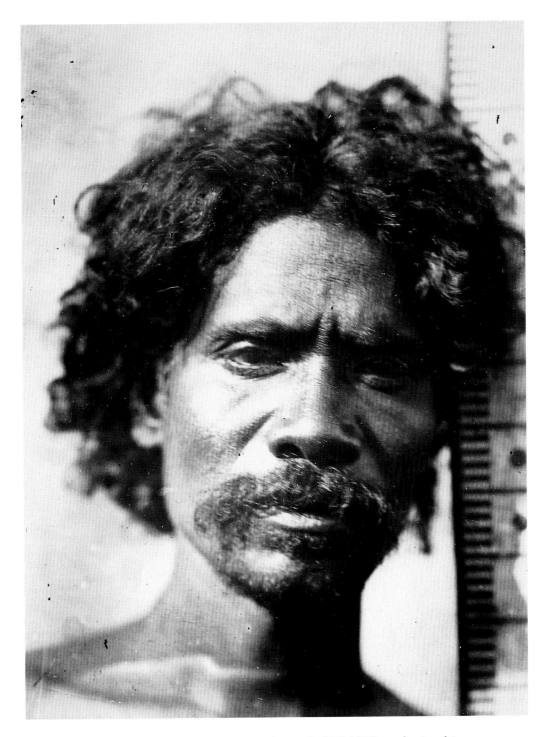

UNKNOWN INDIAN PHOTOGRAPHER, *Kurumba man's head, Nilgiri Hills, ca. 1873* (cat. 64)

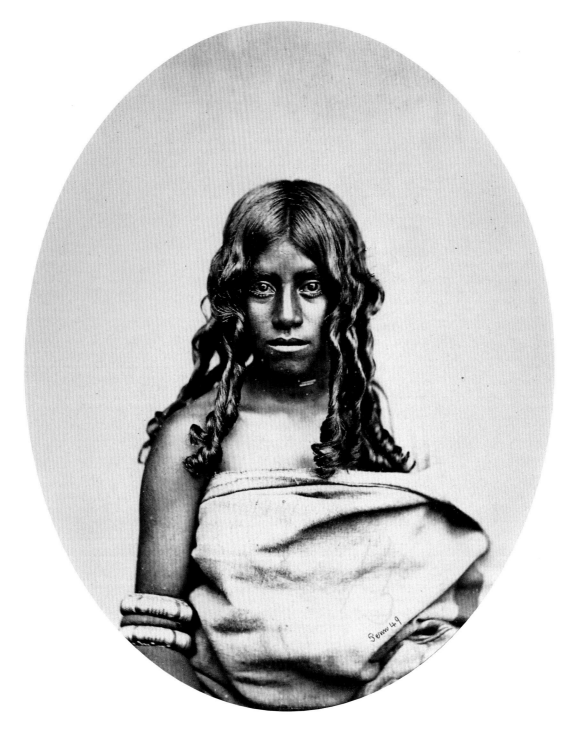

ALBERT THOMAS WATSON PENN, *Toda woman*, 1870s (cat. 66)

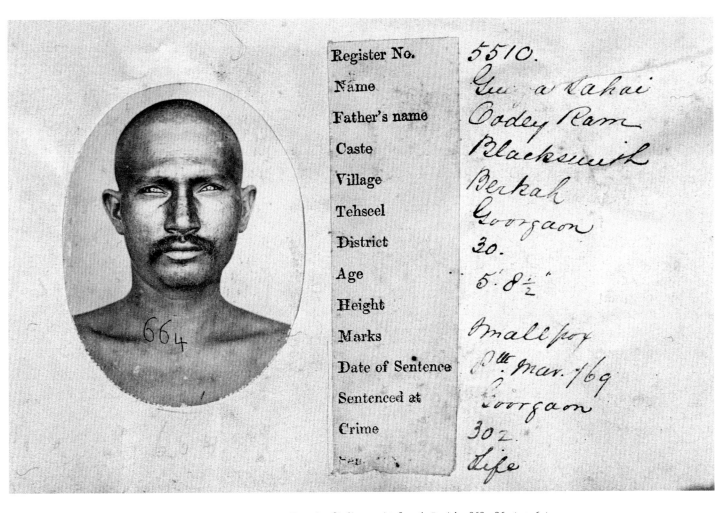

UNKNOWN PHOTOGRAPHER, *Portraits of Indian convicts from the Punjab*, 1868–1869 (cat. 69)

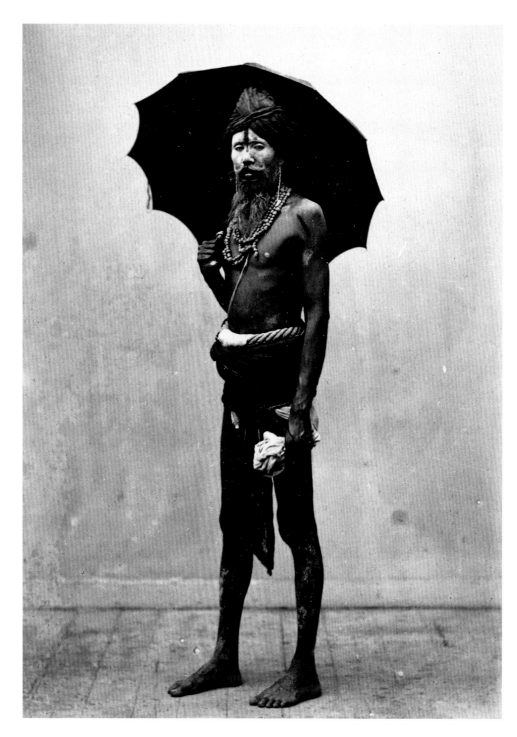

UNKNOWN PHOTOGRAPHER, *A town fakir*, 1860s (cat. 71)

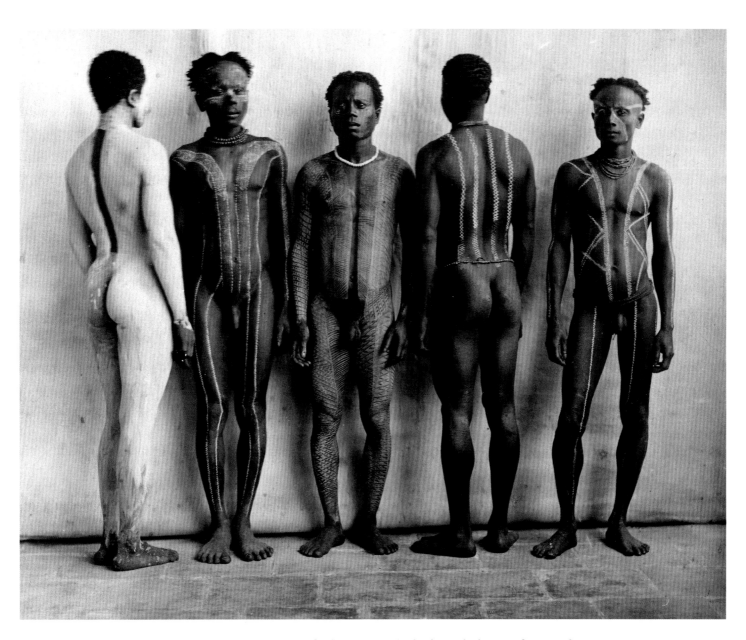

MAURICE VIDAL PORTMAN, *Group of Andamanese men painted with Og and Tala-og, ca. 1893* (cat. 76)

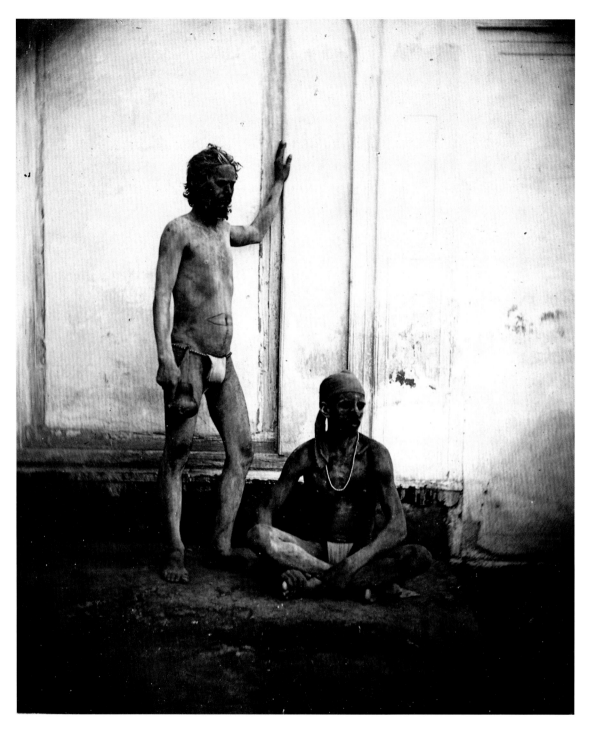

SHEPHERD & ROBERTSON, *Fakirs, ca.* 1862 (cat. 81)

FELICE BEATO, *Old observatory near Delhi, 1858* (cat. 83)

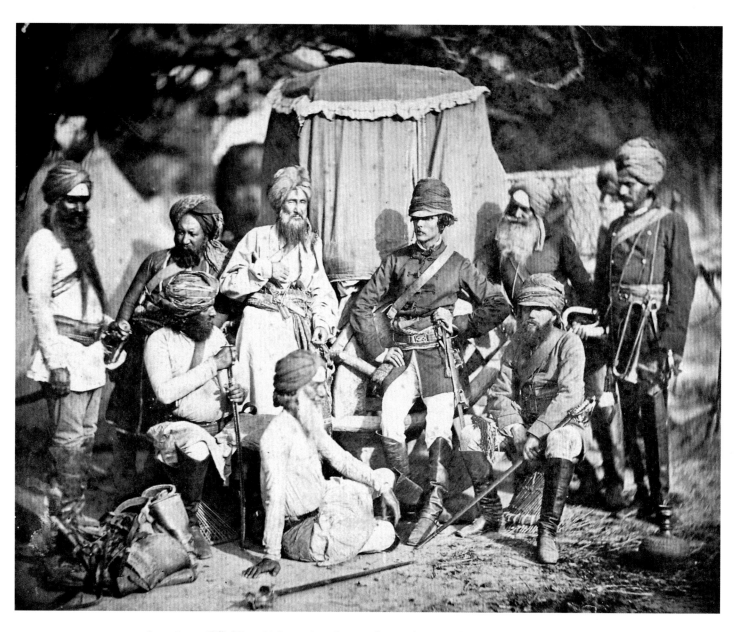

FELICE BEATO, *Clifford Henry Mecham and Dr. Thomas Anderson with a group of Hodson's Horse*, 1858 (cat. 86)

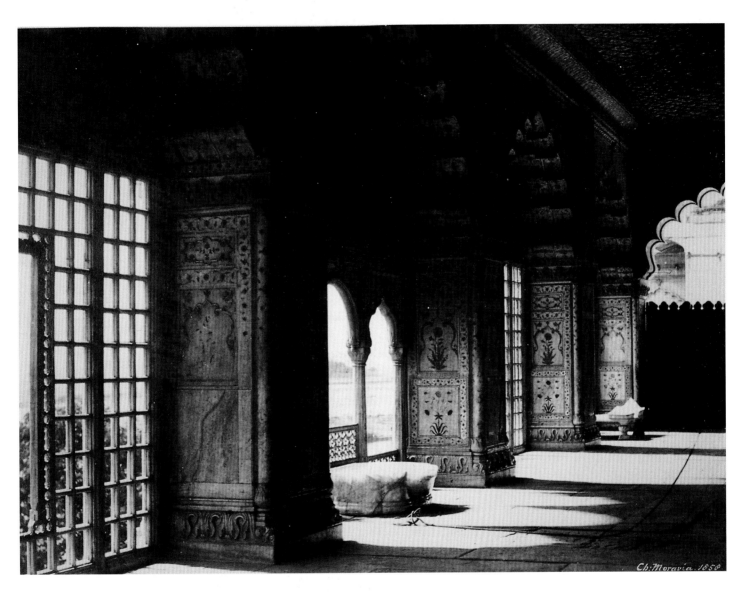

CHARLES MORAVIA, *The crystal throne in the Diwan-i-Khas, Delhi*, 1858 (cat. 89)

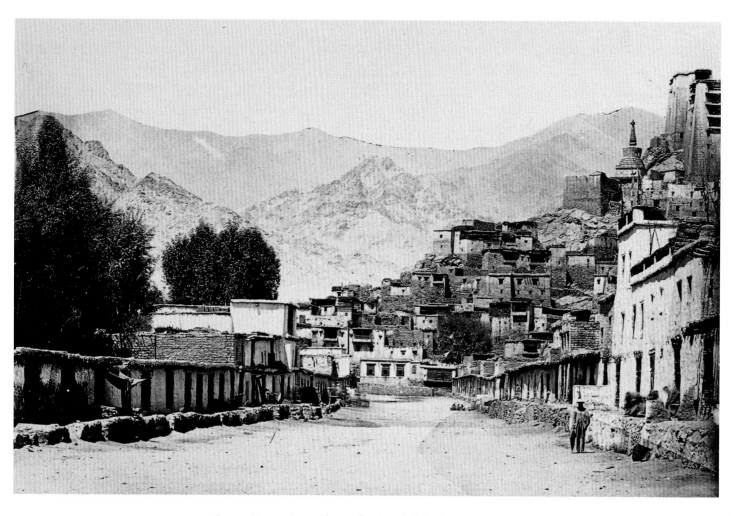

CAPTAIN MELVILLE CLARK, *The city of Le, the capital of Ladac*, 1862 (cat. 90)

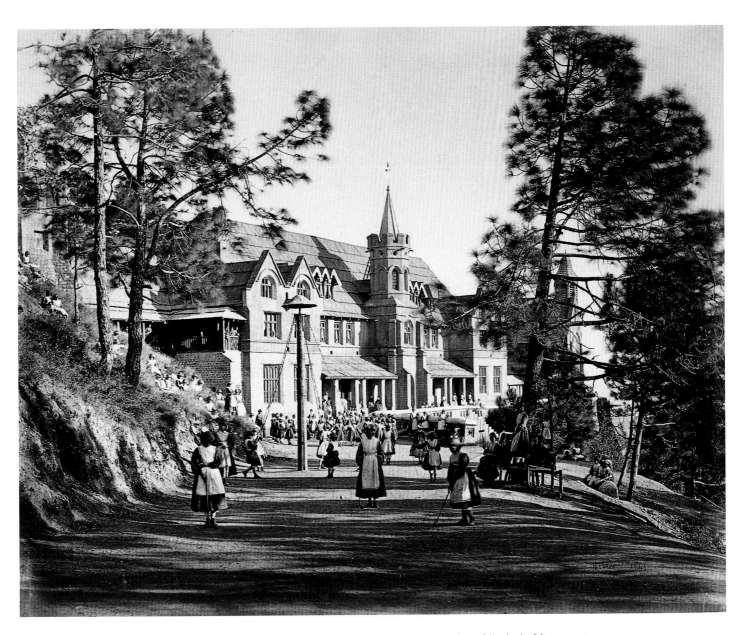

SAMUEL BOURNE, *The Lawrence Military Asylum, Sanawar, girls at play in front of the school*, 1864 (cat. 93)

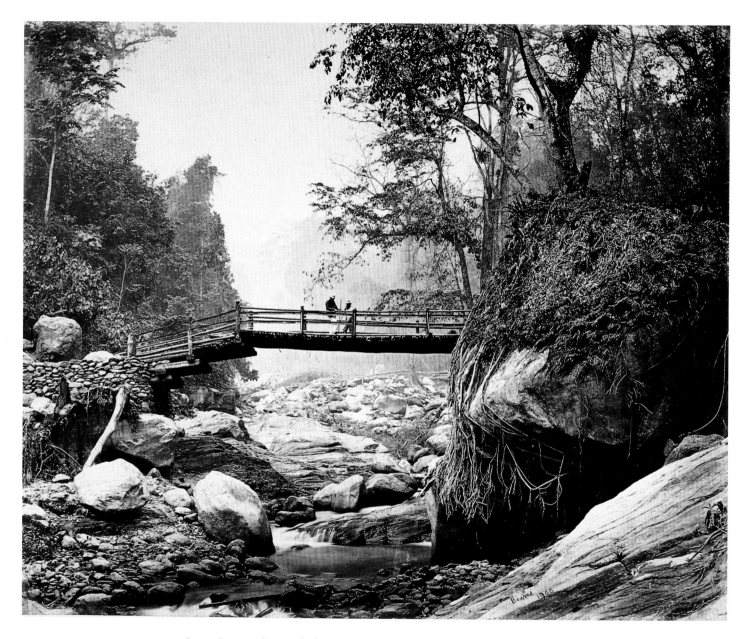

SAMUEL BOURNE, *Picturesque bridge over the Rungnoo below Ging, Darjeeling, ca. 1869* (cat. 97)

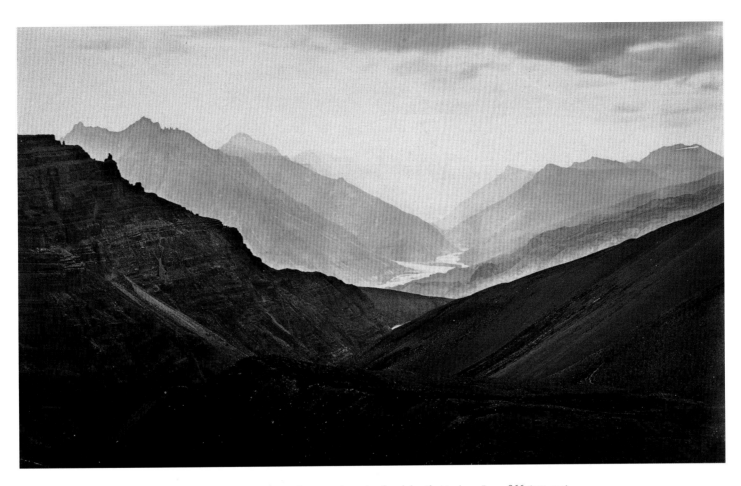

Samuel Bourne, *Evening on the mountains – view from below the Manirung Pass*, 1866 (cat. 102)

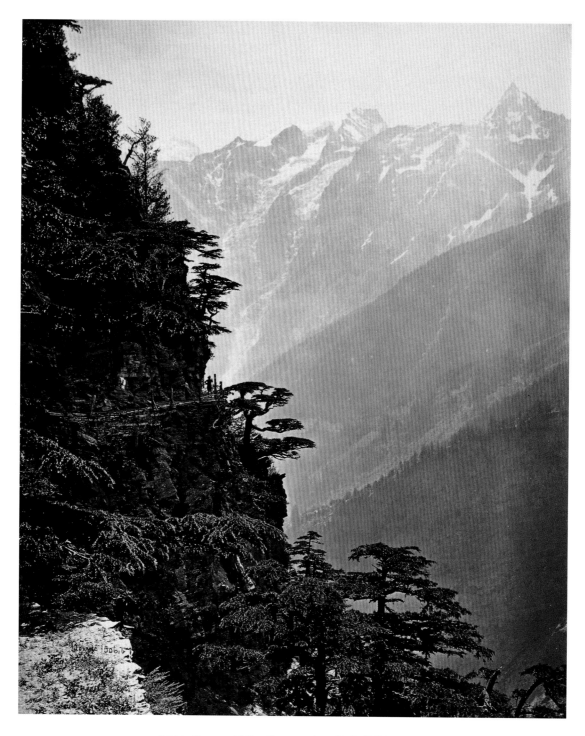

Samuel Bourne, *A 'bit' on the new road near Rogi*, 1866 (cat. 104)

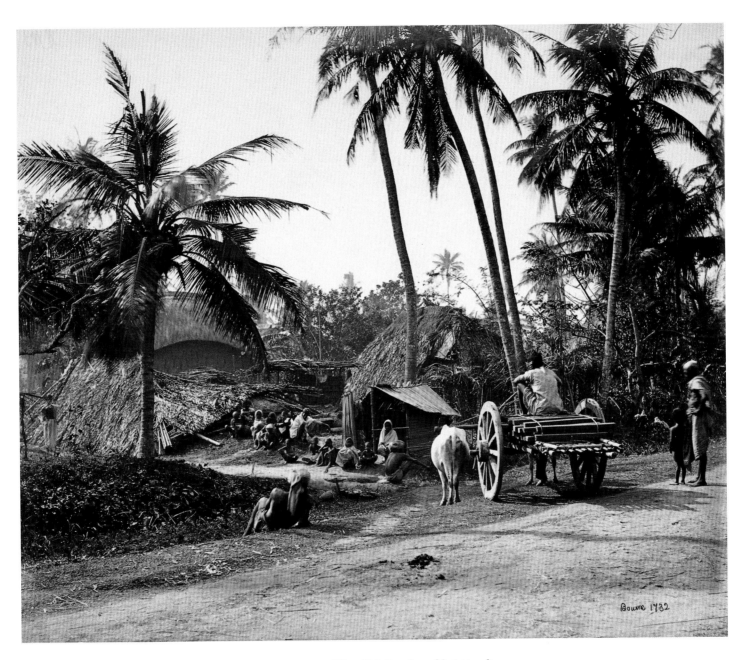

SAMUEL BOURNE, *Village life in Bengal, ca. 1867* (cat. 106)

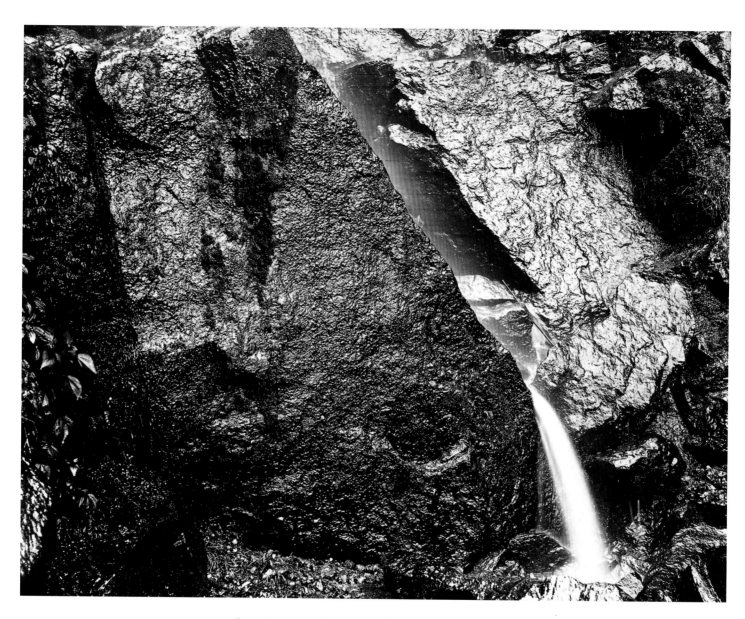

Donald Horne Macfarlane, *Rocks, Darjeeling,* ca. 1862 (cat. 109)

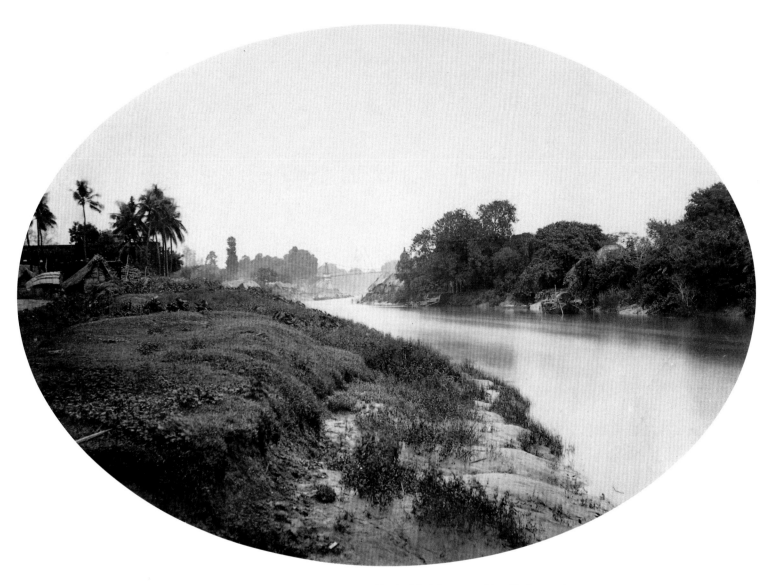

Donald Horne Macfarlane, *Tolly's Nullah, Calcutta, ca.* 1860–1863 (cat. 110)

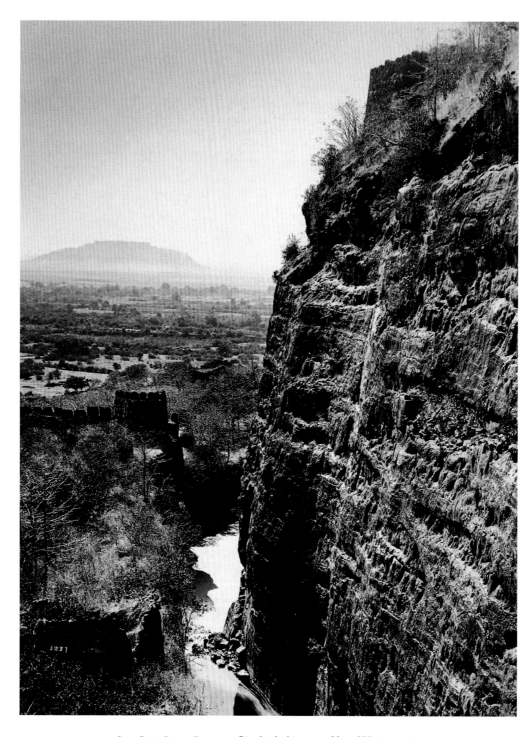

Lala Deen Dayal, *East scarp of Daulatabad Fort, ca.* 1884–1888 (cat. 115)

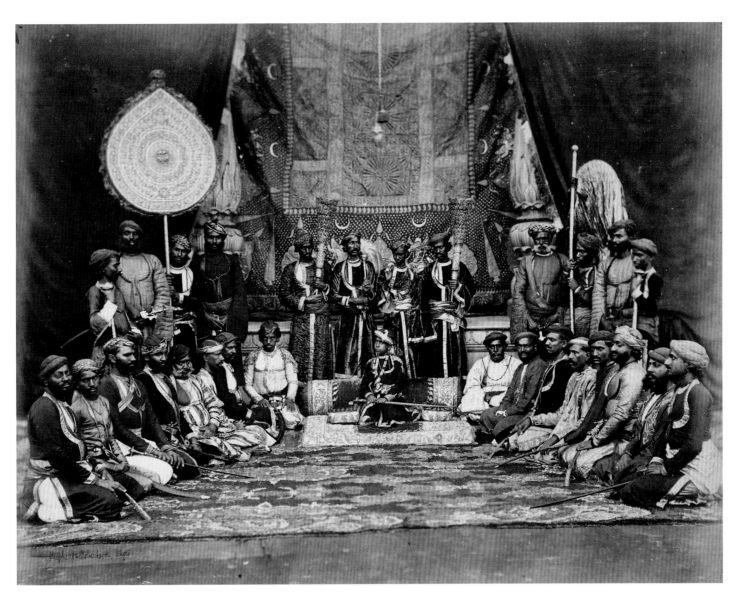

SHEPHERD & ROBERTSON, *Durbar at Bharatpur, 1862* (cat. 117)

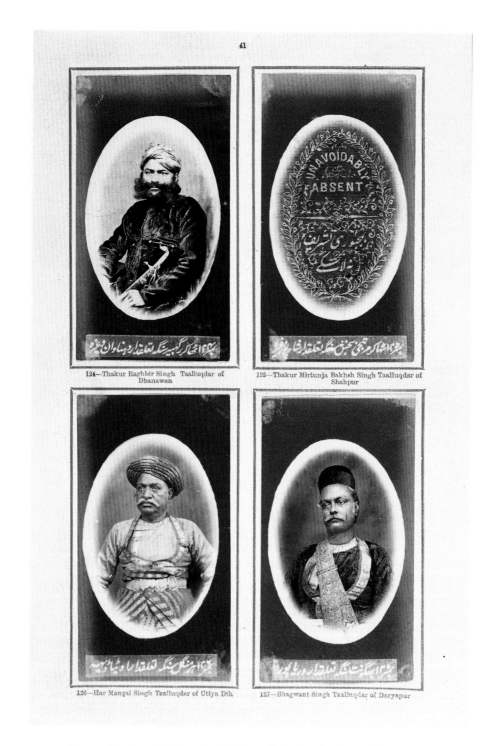

DAROGAH HAJI ABBAS ALI, *Portraits of the Rajas and Taluqdars of Oudh*, ca. 1880 (cat. 118)

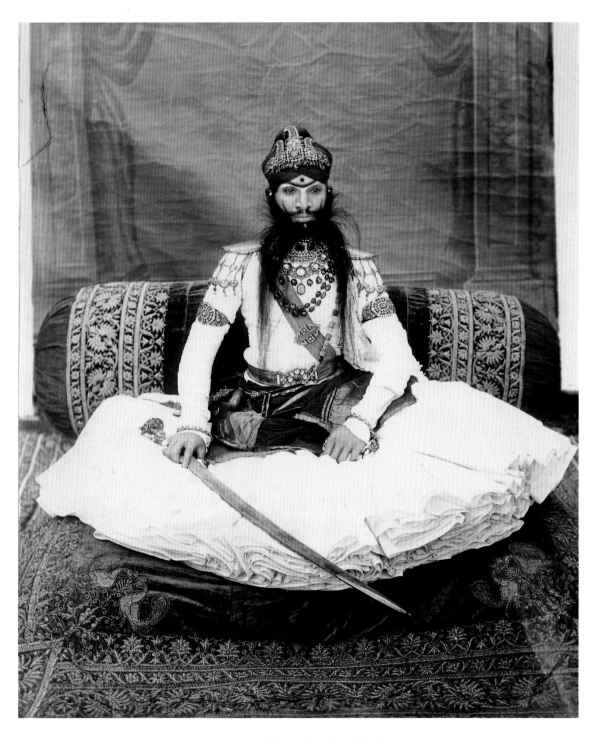

GANPATRAO ABAJEE KALE, *Sir Raghubir Singh, Maharao of Bundi, ca.* 1900 (cat. 124)

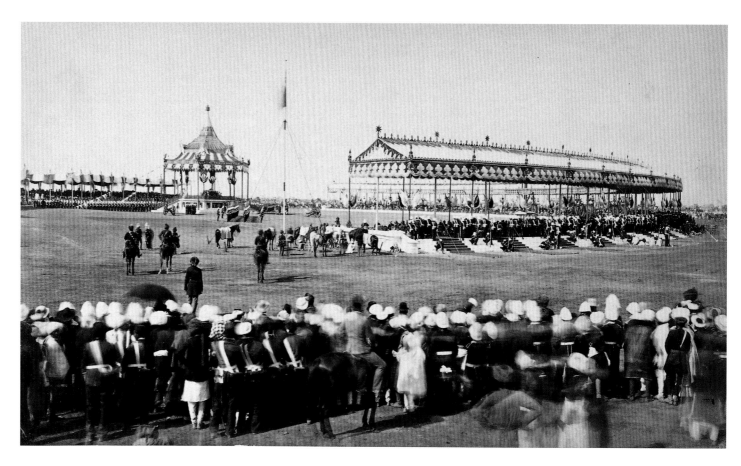

Bourne & Shepherd, *The amphitheatre at the Imperial Assemblage, Delhi*, 1877 (cat. 129)

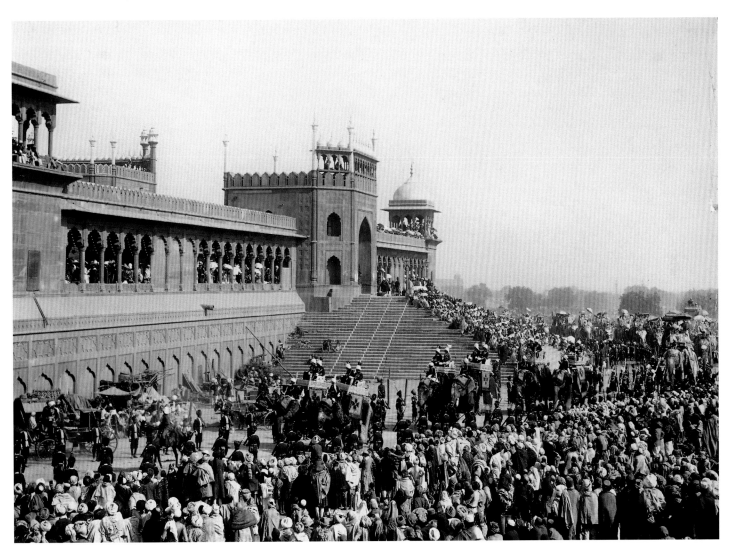

WIELE & KLEIN, *The Delhi Durbar: elephant procession of the Viceroy's staff passing the Jami Masjid, 29 December 1902* (cat. 132)

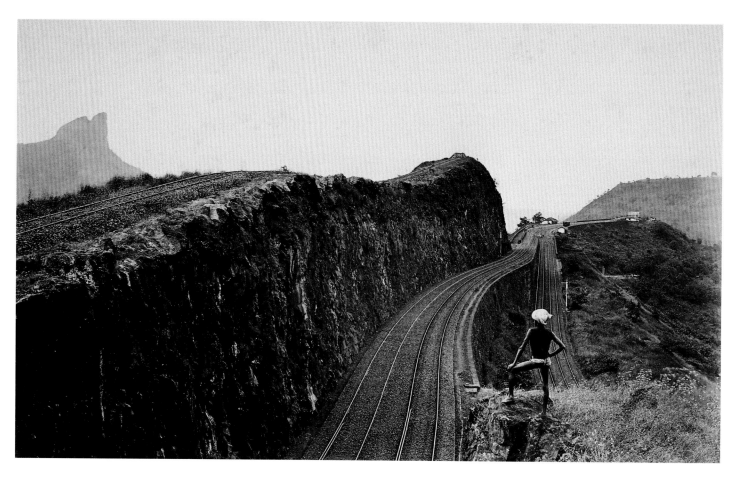

BOURNE & SHEPHERD, *Reversing station on the Bhore Ghat Incline, ca. 1870* (cat. 135)

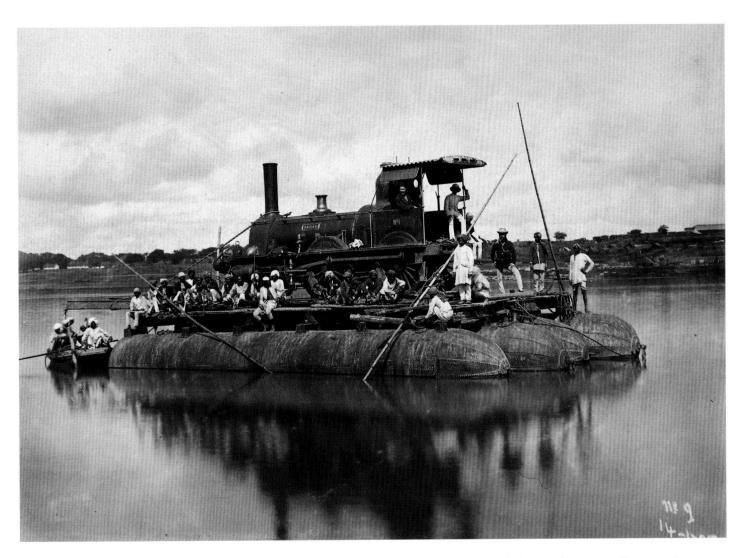

UNKNOWN PHOTOGRAPHER, *Locomotive 'Akbar' being ferried across the Jumna during construction of the railway bridge at Kalpi, 14 January 1887* (cat. 137)

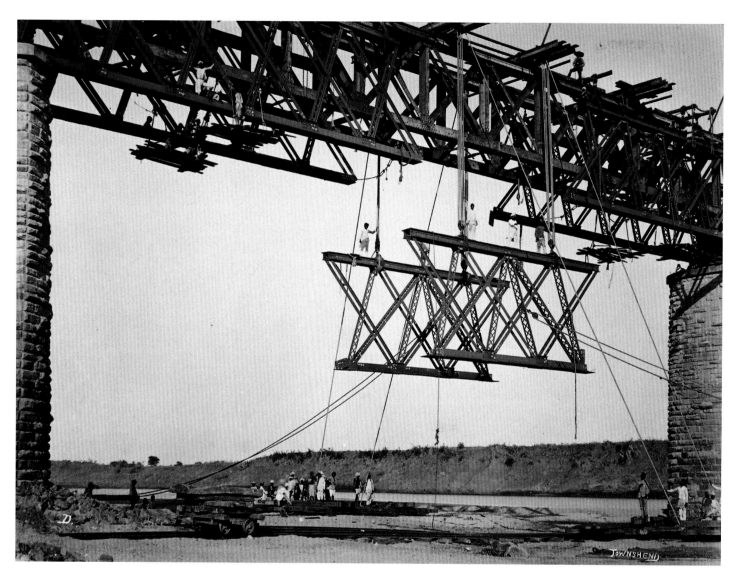

J.C. Townshend, *Weingunga Bridge, conversion from metre to broad gauge, ca. 1890* (cat. 138)

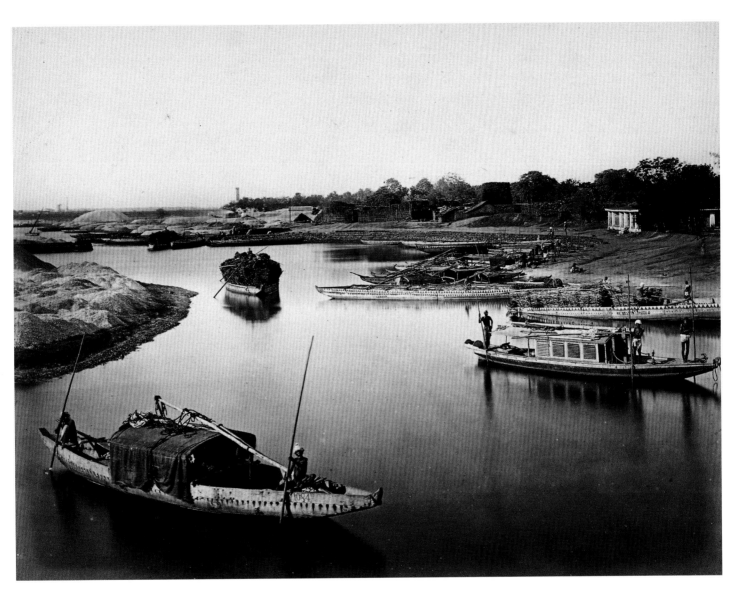

UNKNOWN PHOTOGRAPHER, *Scene on the Madras Canal*, 1860s (cat. 143)

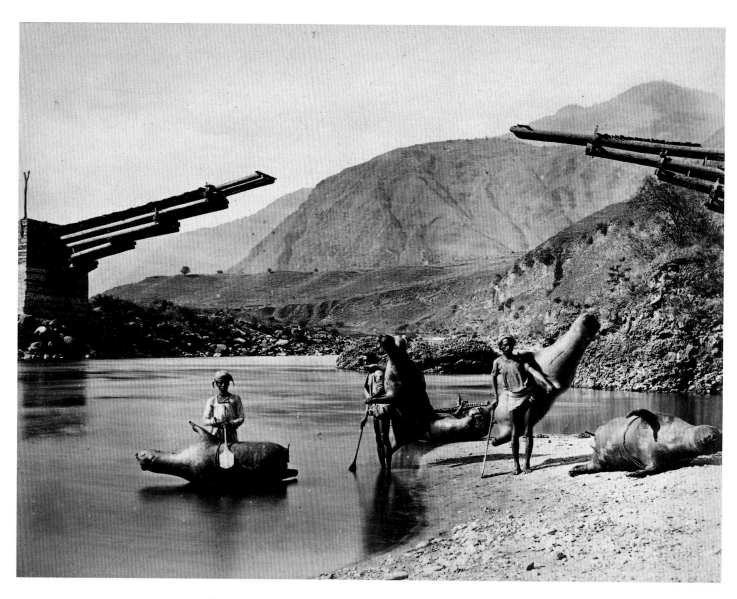

Unknown Photographer, *Mussocks for crossing the River Beas*, 1860s (cat. 145)

UNKNOWN PHOTOGRAPHER, *Man drawing water at a well*, 1860s (cat. 146)

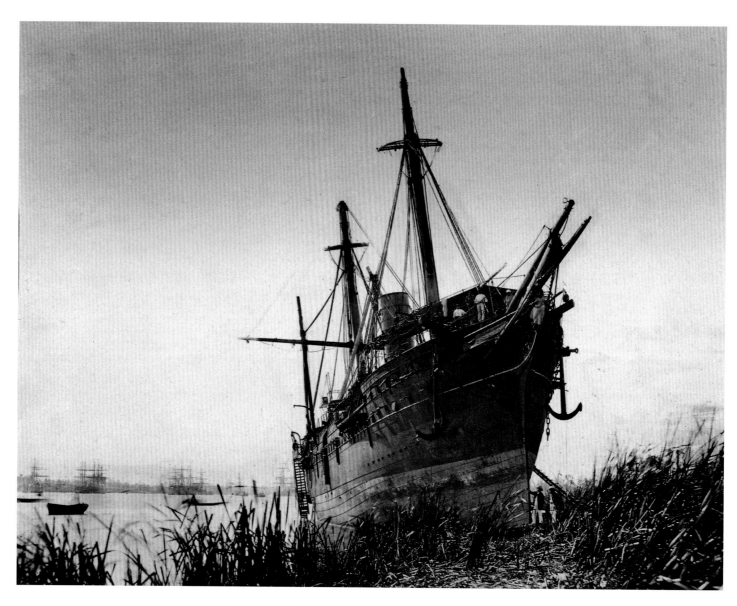

J.F. Pearson (attrib.), *Ship aground after the Calcutta Cyclone*, 1864 (cat. 148)

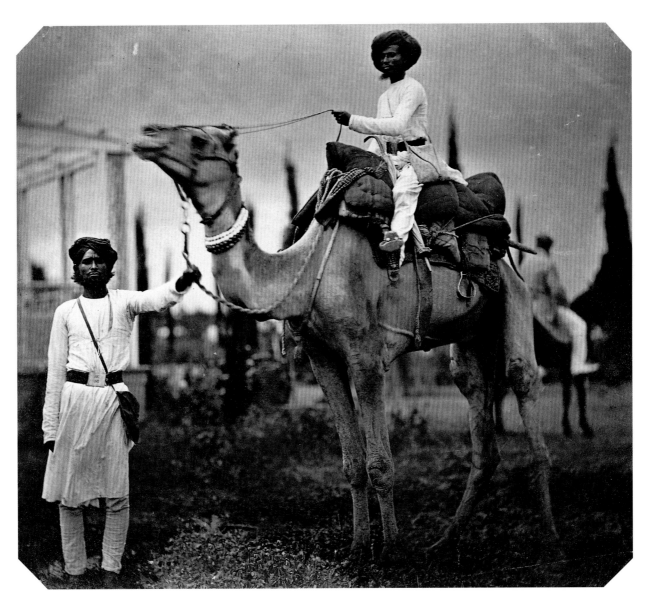

UNKNOWN PHOTOGRAPHER, *Sowaree camels*, early 1860s (cat. 150)

UNKNOWN PHOTOGRAPHER, *Lady Louisa Bruce, daughter of the Viceroy Lord Elgin, with her pet deer,*
Simla, 1863 (cat. 152A)

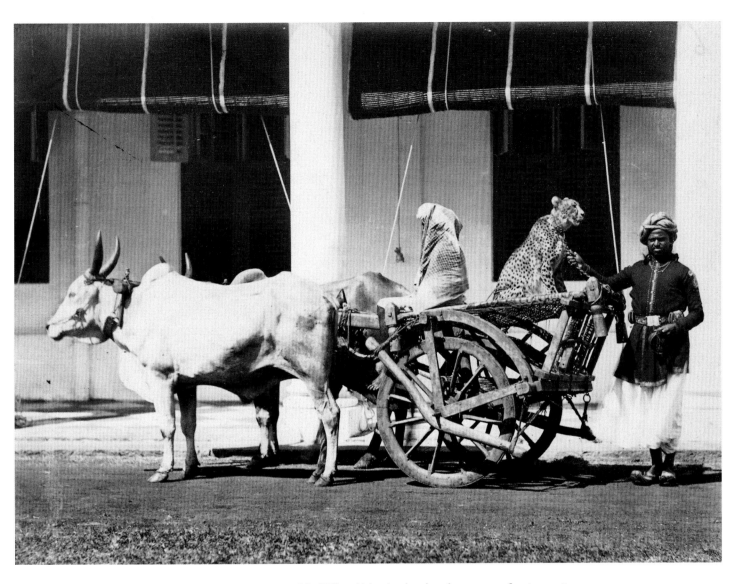

Unknown Photographer, *Rajah of Vallur with hunting cheetahs and country cart, 1875 (cat. 153)*

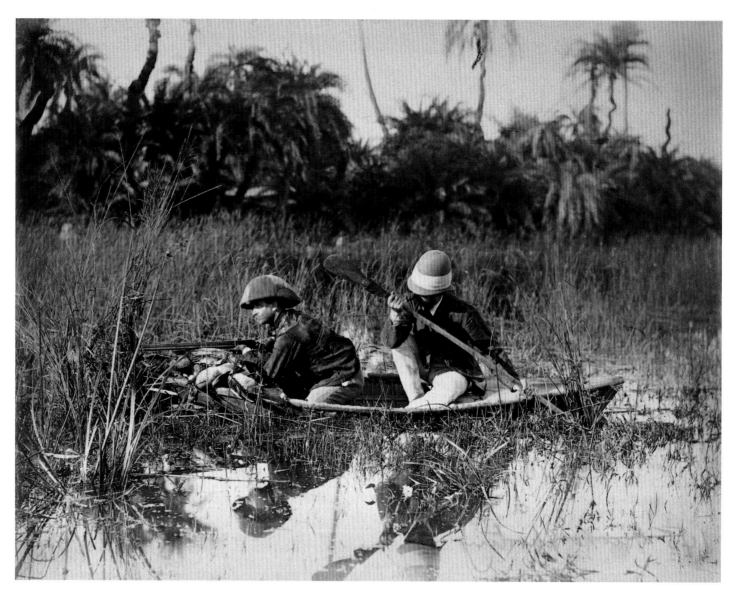

WILLOUGHBY WALLACE HOOPER, *Duck shooting*, early 1870s (cat. 155)

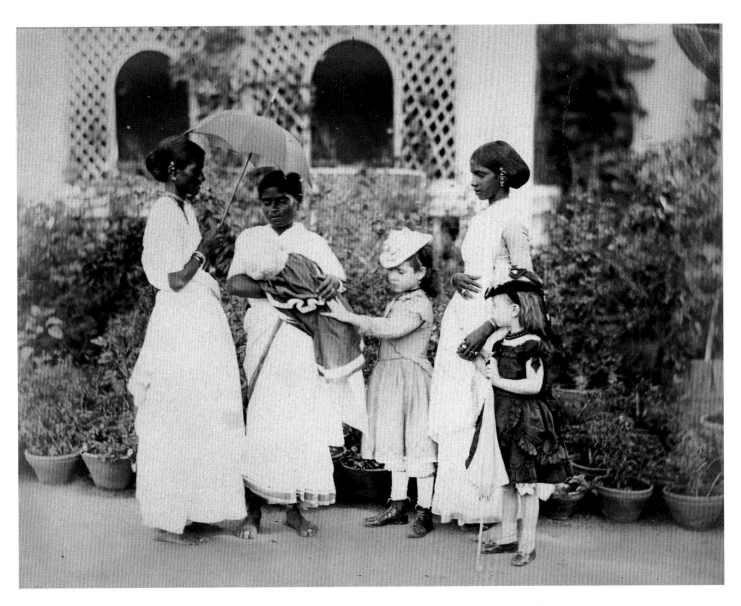

WILLOUGHBY WALLACE HOOPER (attrib.), *Ayahs with English children, 1880s (cat. 156)*

Captain Frederick Kilgour, *View from the interior of the Judge's House, Madura*, 1874–1876 (cat. 158)

ROBERT PHILLIPS, *Cane bridge on the River Tista, Darjeeling, early 1870s* (cat. 160)

BOURNE & SHEPHERD, *Bourne & Shepherd photographers with their equipment at the Delhi Durbar, 1902–1903* (cat. 166)

THE CATALOGUE

Mirror with a memory: the Daguerreotype in India

Asterisk denotes plate illustration

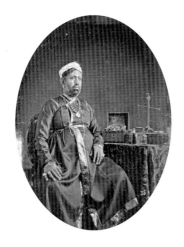

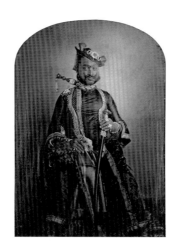

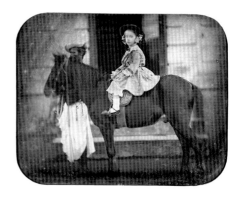

1* UNKNOWN PHOTOGRAPHER, *Daguerreotype portrait of an Indian merchant*, 1850s

Hand-tinted daguerreotype, 14 × 10.3 cm

Howard and Jane Ricketts Collection

2 UNKNOWN PHOTOGRAPHER, *Daguerreotype portrait of Jaswant Rao Ponwar, Raja of Dhar*, early 1850s

Hand-tinted daguerreotype, 17.9 × 12.9 cm

British Library OIOC Photo 67 (1)

3 UNKNOWN PHOTOGRAPHER, *Daguerreotype portrait of a European child with Indian servant*, ca. 1850.

Whole-plate daguerreotype, 12 × 15.3 cm

Howard and Jane Ricketts Collection

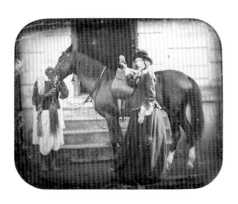

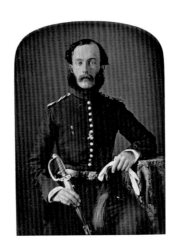

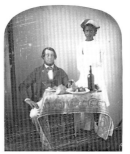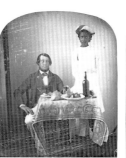

4 UNKNOWN PHOTOGRAPHER, *Daguerreotype portrait of a European lady with Indian syce*, ca. 1850.

Whole-plate daguerreotype, 12.1 × 15.4 cm

Howard and Jane Ricketts Collection

5* JAMES WILLIAM NEWLAND, *Daguerreotype portrait of an Army Officer*, 1850s

Hand-tinted daguerreotype, 8.9 × 6.5 cm

British Library OIOC Photo 922 (1)

6 JAMES WILLIAM NEWLAND, *Stereoscopic daguerreotype portrait of a European with his Indian servant*, 1850s

Stereoscopic daguerreotype, two images, each 7.5 × 6 cm

Howard and Jane Ricketts Collection

Double Vision: the Stereoscope

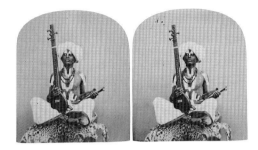

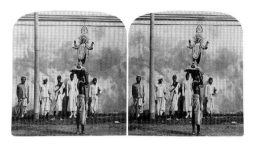

7 ALLAN NEWTON SCOTT, *Indian Musician, Hyderabad district, ca.* 1862
 Albumen prints, each 7.7 × 7.7 cm
 Howard and Jane Ricketts Collection

8 ALLAN NEWTON SCOTT, *'Rest, Warrior, Rest',* ca. 1862.
 Albumen print, 7.2 × 7.3 cm
 Plate 11 of A.N. Scott, *Sketches of India, taken at Hyderabad and Secunderabad, in the Madras Presidency* (London, 1862)
 British Library OIOC Photo 961 (11)

9 JAMES RICALTON for UNDERWOOD & UNDERWOOD, *Procession of the goddess Kali, Calcutta,* ca. 1900
 Gelatin silver prints, each 8.1 × 7.7 cm
 From the Underwood Travel Library: *India through the Stereoscope. A Journey through Hindustan* (New York, ca. 1903)
 British Library OIOC Photo 181

10 *Stereoscopic viewer on stand, ca.* 1860
 Unknown manufacturer
 Howard and Jane Ricketts Collection

11 *Portable stereoscopic viewer, ca.* 1860
 Carpenter and Westley, 24 Regent Street, London
 Howard and Jane Ricketts Collection

Amateur Enthusiasms

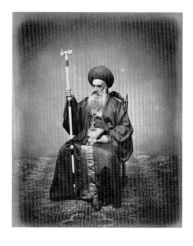

12 ALFRED HUISH, *Portraits of Sir William and Lady Elizabeth Gomm*, 1851

Salt prints, 12.7 × 10.2 cm

From an album by Captain Alfred Huish, Bengal Artillery, comprising views taken 1848–1852.

Photograph A shown here

Howard and Jane Ricketts Collection

13 JOHN CONSTANTINE STANLEY, *Portraits of Lady Canning and Colonel Eyre and his pet Guddah, Calcutta, ca.* 1859

Albumen prints, 15.1 × 13.5 cm and 14.2 × 12.1 cm

Photograph B shown here

Howard and Jane Ricketts Collection

14★ WILLIAM JOHNSON and WILLIAM HENDERSON, *An Eastern Bishop*, 1857

Albumen print, 24.3 × 19.8 cm

Published in *The Indian amateurs photographic album*, Issue 11, September 1857

Howard and Jane Ricketts Collection

15 REVD. JOSEPH MULLENS, *On the Applications of Photography in India*

Journal of Photographic Society of Bengal, no. 1, 21 Jan 1857, pp. 33–38

British Library P.P.1912.m.

16 *Catalogue of Pictures in the Exhibition of the Photographic Society of Bengal, 4th March 1857* (Calcutta, 1857)

British Library 8907.f.23

17 J.P. Beadle, *Report of the Bengal Photographic Society Exhibition,* 1864

Journal of Bengal Photographic Society , vol. 2, no. 7, March 1864, pp. 77–87

British Library P.P. 1912.ma

18 WILLIAM CROKER, *Notes on Photographic Trials, commenced April 1859*

Manuscript

British Library OIOC Mss Eur E421

19 WILLIAM CROKER, *View on the Jhelum at Srinagar*, early 1860s

Albumen print, 9.2 × 28.6 cm

British Library, OIOC Mss Eur E421 (8)

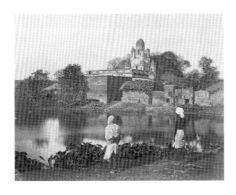

20 FREDERICK FIEBIG, *The 'Black Pagoda', Chitpore Road, Calcutta, ca. 1850*
Hand-coloured salt print, 17 × 22 cm
British Library OIOC Photo 247/1 (13)

21* FREDERICK FIEBIG, *Grain bazaar on the Chitpore Road, Calcutta, ca. 1850*
Hand-coloured salt print, 16.7 × 23.8 cm
British Library OIOC Photo 247/4 (56)

22* AHMAD ALI KHAN, *Portrait of Nawab Raj Begum Sahibah of Oudh, ca. 1855*
Salt print, 12.2 × 9.8 cm, overall 29.8 × 21.4 cm
British Library OIOC Photo 500 (3)

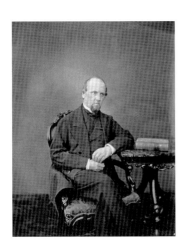

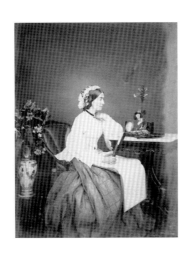

23* BENJAMIN SIMPSON, *Portrait of Lord Canning, 1861*
Albumen print, 28.3 × 22 cm
Howard and Jane Ricketts Collection

24* JOSIAH ROWE, *Portrait of Lady Canning, 1861*
Albumen print, 28.3 × 22.1 cm
Howard and Jane Ricketts Collection

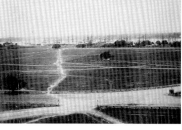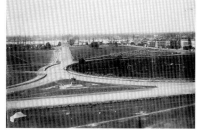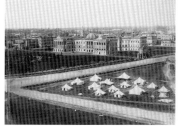

25 JOSIAH ROWE, *Panoramic view of Calcutta from*
 the Ochterlony Monument, 1859
 Eight albumen prints, joined 16 × 175 cm
 British Library OIOC Photo 147/1 (49)

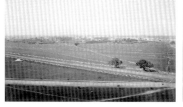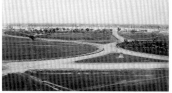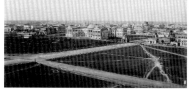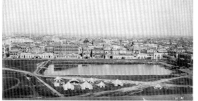

26 SAMUEL BOURNE, *Panoramic view of Calcutta*
 from the Ochterlony Monument, 1868–1869
 Seven albumen prints, joined 17.8 × 216.1 cm
 British Library OIOC Photo 29 (18–24)

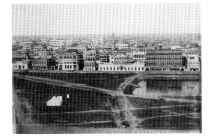 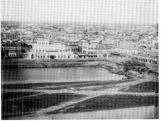 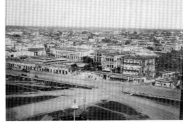 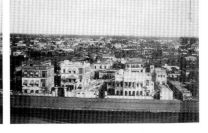

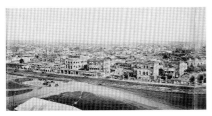 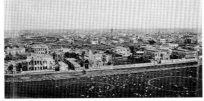 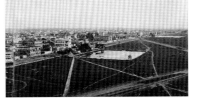

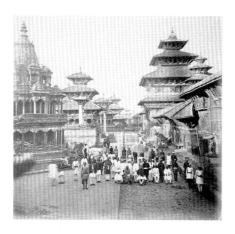

27* CLARENCE COMYN TAYLOR, *The Durbar Square at Patan, Nepal, from the south,* 1863–1865
Albumen print, 32.8 × 34.1 cm
British Library OIOC Photo 855 (7)

28 SHAMARANDRA CHANDRA DEB BARMAR, *Portrait of a young girl from Tripura,* 1890s
Platinum print, 25.4 × 20.2 cm
British Library OIOC Photo 430/73 (35)

'A Glorious Galaxy of Monuments': Photography and Architecture

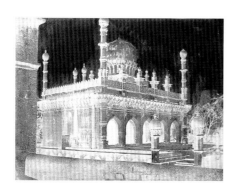

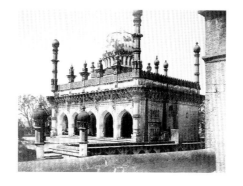

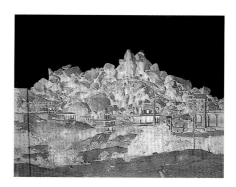

29* THOMAS BIGGS, *Mosque of Ibrahim Rauza, Bijapur,* 1855
Waxed paper negative, 28.5 × 38.2 cm
British Library OIOC Photo 1000 (971 neg)

30* THOMAS BIGGS, *Mosque of Ibrahim Rauza, Bijapur,* 1855
Albumen print from a waxed paper negative, 29.2 × 38.6 cm
Plate 33 of Philip Meadows Taylor and James Fergusson, *Architecture at Beejapoor* (London, 1866)
Howard and Jane Ricketts Collection

31 WILLIAM HENRY PIGOU, *Chamundi Temple, Chitradurga, ca.* 1857
Waxed paper negative, 29.8 × 39.5 cm
British Library OIOC Photo 1000 (1069 neg)

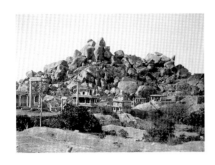

32 WILLIAM HENRY PIGOU, *Chamundi Temple,*
Chitradurga, ca. 1857

Albumen print from a waxed paper negative,
27.9 × 38.4 cm

Plate 76 of Philip Meadows Taylor and James
Fergusson, *Architecture in Dharwar and*
Mysore (London, 1866).

Howard and Jane Ricketts Collection

33* LINNAEUS TRIPE, *View of the hill fort at*
Trimium [Tirumayam] from top of gateway
of the outer wall, 1858

Albumenised salt print, 24.3 × 27.6 cm

Plate 7 of Linneaus Tripe, *Photographic views*
of Poodoocottah (Madras, 1858).

British Library OIOC Photo 952 (7)

34 JOHN MURRAY, *View in the garden of the Taj*
Mahal, Agra, early 1860s

Waxed paper negative, 37.2 × 46.6 cm

British Library OIOC Photo 35 (13)

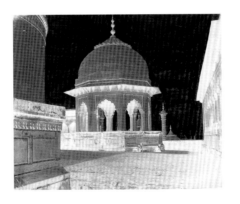

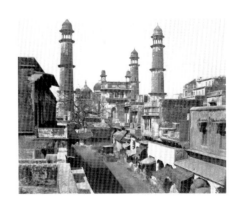

35* JOHN MURRAY, *Detail of the outer tower of the Jamat*
Khana in the Taj Mahal enclosure, Agra,
6 February 1862

Waxed paper negative, 37.5 × 46.5 cm

British Library OIOC Photo 35 (15)

36 JOHN MURRAY, *Chhatri on the roof of the Taj*
Mahal, Agra, early 1860s

Waxed paper negative, 37.8 × 47 cm

British Library OIOC Photo 35 (17)

37* JOHN MURRAY, *Street scene in Muttra, with the*
Jami Masjid in the background, mid-1850s

Salt print, 36.7 × 45.3 cm

British Library OIOC Photo 101 (26)

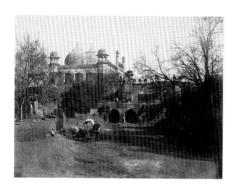

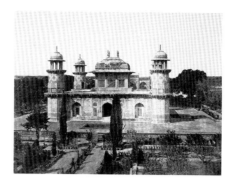

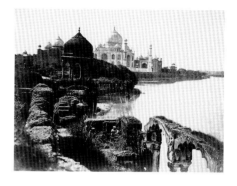

38 JOHN MURRAY, *The Jami Masjid, Agra,*
mid-1850s
Salt print, 35.4 × 45.8 cm
British Library OIOC Photo 101 (12)

39 JOHN MURRAY, *Itimad-ud-daulah's Tomb, Agra,*
mid-1850s
Salt print, 36 × 44.7 cm
British Library OIOC Photo 101 (14)

40 JOHN MURRAY, *The Taj Mahal from the east with*
ruins in the foreground, ca. 1858
Albumen print from a waxed paper negative,
40.1 × 45.4 cm
Howard and Jane Ricketts Collection

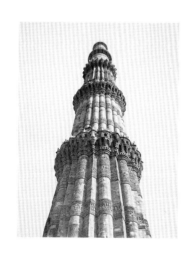

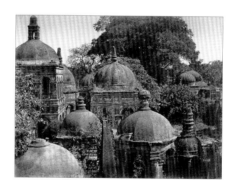

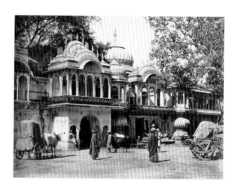

41 ROBERT and HARRIET TYTLER, *The Qutb Minar,*
Delhi, 1858
Two albumen prints, 108.4 × 40.2 cm
Photograph A shown here
British Library OIOC Photo 193 (18–19)

42* DONALD HORNE MACFARLANE (attrib.),
Dutch tombs at Surat, ca. 1860
Albumen print, 22.9 × 29.8 cm
Howard and Jane Ricketts Collection

43* EUGENE CLUTTERBUCK IMPEY, *Chhatri at Rajgarh,*
Rajasthan, ca. 1862
Albumen print, 22.5 × 28.5 cm
Plate 57 of E.C. Impey, *Delhi, Agra, and*
Rajpootana, illustrated by eighty photographs
(London, 1865)
British Library OIOC Photo 971 (57)

44 ROBERT GILL, *Verandah of Ajanta Cave Temple XI*, 1868

Two printing-out paper prints made *ca.* 1890 from original wet collodion negatives, each 10.7 × 18.5 cm

Photograph A shown here

British Library OIOC Photo 1001 (2077-2078)

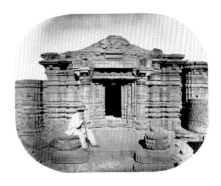

45* ROBERT GILL, *Captain Gill seated in front of the west face of the Chintamani Mahadeva Temple, Kothali, Buldana District, Berar*, 1871

Albumen print, 18.6 × 23.5 cm

British Library OIOC Photo 1001/1 (1975)

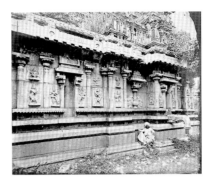

46 EDMUND DAVID LYON, *Wall of the Volkonda Temple, Vijayanagara*, 1868

Printing-out paper print, made *ca.* 1890 from original wet collodion negative, 25.2 × 30.2 cm

British Library OIOC Photo 1001/1 (3140)

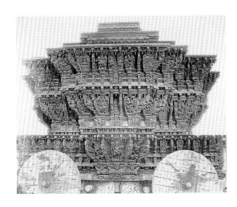

47 EDMUND DAVID LYON, *Side view of the temple car, Srivilliputtur*, 1868

Printing-out paper print, made *ca.* 1890 from original wet collodion negative, 25.1 × 30.2 cm

British Library OIOC Photo 1001/1 (2984)

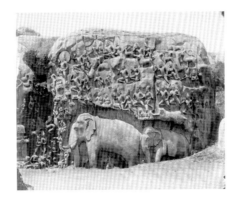

48* EDMUND DAVID LYON, *Right-hand section of Arjuna's Penance, Mamallapuram*, 1868

Printing-out paper print, made *ca.* 1890 from original wet collodion negative, 24.9 × 30 cm

British Library OIOC Photo 1001/1 (3071)

49* LALA DEEN DAYAL, *View of the Stupa at Sanchi from the south-west, during repairs*, 1881

Albumen print, 21.8 × 27.3 cm

British Library OIOC Photo 1001/1 (1342)

50 HENRY COUSENS, *Coping stone fragments from the Amaravati Stupa*, 1884

Printing-out paper print made *ca.* 1890 from original dry collodion negative, 19.3 × 25.7 cm

British Library OIOC Photo 1001/1(2174)

Face to Face: Photographing the People of India

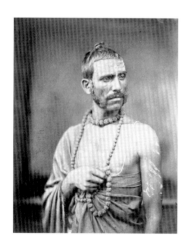

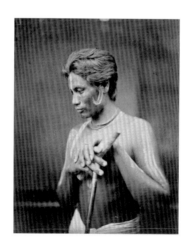

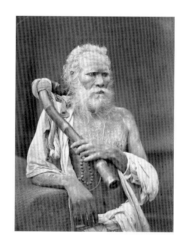

51 UNKNOWN PHOTOGRAPHER, *Kanaujiya Brahmin, Eastern Bengal*, early 1860s

Albumen print, 23.5 × 18.5 cm

British Library OIOC Photo 124 (18)

52* UNKNOWN PHOTOGRAPHER, *Manipuri polo player*, early 1860s

Albumen print, 23.5 × 18.5 cm

British Library OIOC Photo 124 (5)

53 UNKNOWN PHOTOGRAPHER, *Sadhu fakir, Eastern Bengal*, early 1860s

Albumen print, 22.5 × 17.2 cm

British Library OIOC Photo 124 (2)

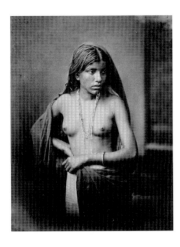

54★ UNKNOWN PHOTOGRAPHER, *Portrait of a young woman, Eastern Bengal, early 1860s*

Albumen print, 22.4 × 18.5 cm

British Library OIOC Photo 124 (33)

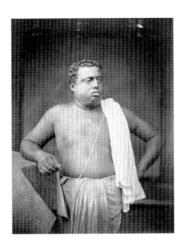

55 UNKNOWN PHOTOGRAPHER, *Portrait of a Brahmin, Eastern Bengal, early 1860s*

Albumen print, 24.2 × 19 cm

British Library OIOC Photo 124 (15)

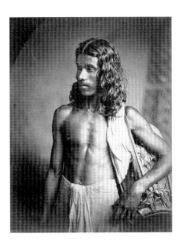

56 UNKNOWN PHOTOGRAPHER, *Banujia Dom, Eastern Bengal, early 1860s*

Albumen print, 23.8 × 18.6 cm

British Library OIOC Photo 124 (23)

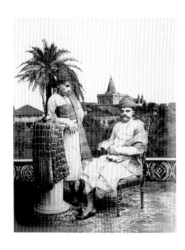

57★ WILLIAM JOHNSON, *Ghur-Baree (Householding) Gosaees, 1850s*

Albumen print, 23.3 × 18 cm

Plate 12 of vol. 1 of William Johnson, *The oriental races and tribes, residents and visitors of Bombay* (2 vols, London, 1863–1866)

British Library OIOC Photo 964/1 (12)

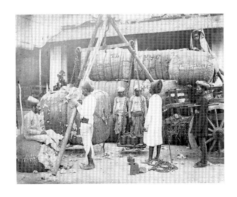

58★ WILLIAM JOHNSON and WILLIAM HENDERSON, *Weighing cotton, Bombay, ca. 1858*

Albumen print, 19.8 × 25.3 cm

Howard and Jane Ricketts Collection

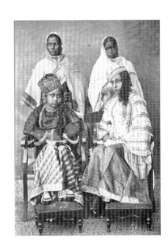

59B★JAMES WATERHOUSE, *The Begum of Bhopal and Shah Jehan in costume for a private entertainment, Bhopal, 1862*

Albumen print, 10.5 × 7.5 cm

The Alkazi Collection of Photography, 98.72.0002.2 (7)

59A JAMES WATERHOUSE, *The Begum of Bhopal and her grandchild*, Bhopal, 1862

Albumen print, 14.4 × 9.8 cm

The Alkazi Collection of Photography, 98.72.0002.2 (8)

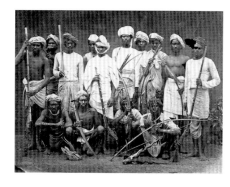

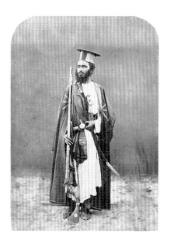

59C JAMES WATERHOUSE, *Bibi Doolan*, Bhopal, 1862

Albumen print, 10.5 × 7.8 cm

The Alkazi Collection of Photography, 98.72.0002.2 (9)

60 JAMES WATERHOUSE, *Bheels of the Vindhyas, Sardarpur*, 1862

Albumen print, 14.8 × 19.6 cm

Alkazi Collection, 98.72.0002.1 (53)

61 HENRY CHARLES BASKERVILLE TANNER, *Sindh types*, 1861–1862

Albumen prints, 18.2 × 13.3 cm, 19.2 × 13.5 cm, 18.2 × 13.5 cm, 16.5 × 11 cm

(a)Sindhi man, (b) Sirdar Khan, chief of the Numrias, (c) Sindhi man and boy, (d)Chandia man from Baluchistan
Photograph B shown here

British Library OIOC Photo 143 (2, 3, 4, 8)

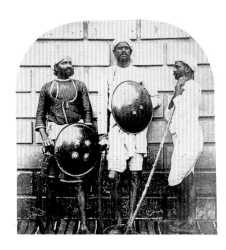

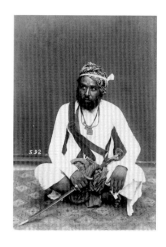

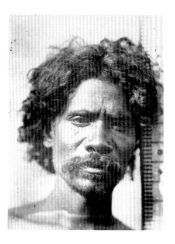

62 UNKNOWN PHOTOGRAPHER, *Bhali Sooltans. Mostly Mahomedans*. Oude, ca. 1862

Albumen print, 19.3 × 17 cm

Plate 79 of John Forbes Watson and John William Kaye, *The People of India* (8 vols, London, 1868–1875)

British Library OIOC Photo 972/2 (79)

63* UNKNOWN INDIAN PHOTOGRAPHER, *Charan Rajput, Jodhpur*, ca. 1890

Albumen print, 13.8 × 9.7 cm

Plate 57 of Hardyal Singh, *Report of the census of 1891. Vol. II. The castes of Marwar illustrated* (Jodhpur, 1894)

British Library OIOC Photo 991 (57)

64* UNKNOWN INDIAN PHOTOGRAPHER, *Kurumba man's head, Nilgiri Hills*, ca. 1873

Albumen print, 25.3 × 18.8 cm

Plate 24 of James Wilkinson Breeks, *An account of the primitive tribes and monuments of the Nilagiris* (London, 1873)

Howard and Jane Ricketts Collection

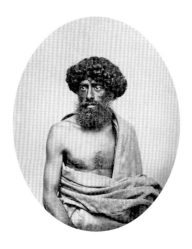

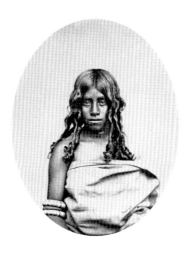

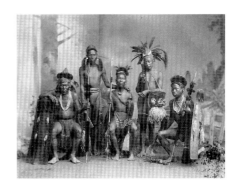

65 ALBERT THOMAS WATSON PENN, *Toda man*, 1870s
Albumen print, 26.5 × 21.3 cm
Penn negative no. 48
Howard and Jane Ricketts Collection

66* ALBERT THOMAS WATSON PENN, *Toda woman*, 1870s
Albumen print, 26.4 × 21.2 cm
Penn negative no. 49
Howard and Jane Ricketts Collection

67 UNKNOWN PHOTOGRAPHER, *Naga group*, 1870s
Albumen print, 20.7 × 26.9 cm
Howard and Jane Ricketts Collection

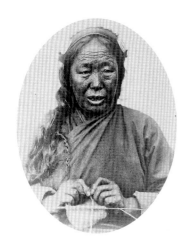

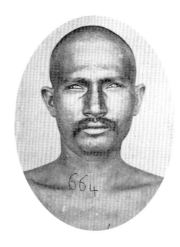

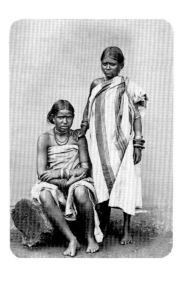

68 BENJAMIN SIMPSON, *Old Bhutea woman*, ca. 1862
Albumen print, 19.1 × 14 cm (oval image)
Plate 55 of John Forbes Watson and John William Kaye, *The People of India* (8 vols, London 1868–1875)
Howard and Jane Ricketts Collection

69* UNKNOWN PHOTOGRAPHER, *Portraits of Indian convicts from the Punjab*, 1868–1869
Albumen prints, 6 prints each approx 6.2 × 4 cm (oval), with letterpress and mss notes
Howard and Jane Ricketts Collection

70 UNKNOWN PHOTOGRAPHER, *Portraits of Kota men and women*, ca. 1862
Two albumen prints, 18.4 × 13.1 cm and 18.3 × 12.9 cm
Published as plates 435 and 434 respectively in John Forbes Watson and John William Kaye, *The People of India* (8 vols, London, 1868–1875)
Photograph B shown here
Howard and Jane Ricketts Collection

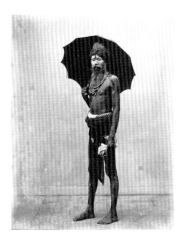

71★ UNKNOWN PHOTOGRAPHER, *A town fakir*, 1860s
Albumen print, 23.6 × 18.5 cm
Howard and Jane Ricketts Collection

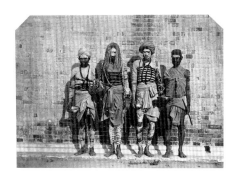

72 UNKNOWN PHOTOGRAPHER, *Group of fakirs*, 1860s
Albumen print, 19.4 × 26.7 cm
Howard and Jane Ricketts Collection

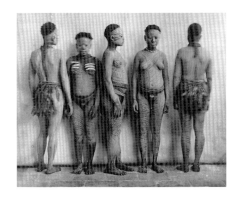

73 MAURICE VIDAL PORTMAN, *Group of Andamanese women painted with Og*, ca. 1893
Platinum print, 28.4 × 35.2 cm
British Library OIOC Photo 188/7 (31)

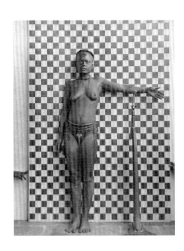

74 MAURICE VIDAL PORTMAN, *Keliwa woman of the Ta-Keda tribe, aged about 45 years*, ca. 1893
Platinum print, 34.4 × 26.8 cm
British Library OIOC Photo 188/11 (20)

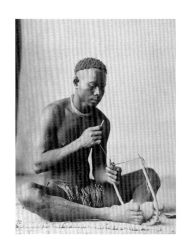

75 MAURICE VIDAL PORTMAN, *Making the pig arrow, Andaman Islands*, ca. 1893
Platinum print, 34.1 × 27 cm
British Library OIOC Photo 188/7 (32)

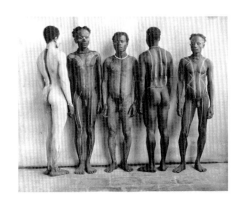

76★ MAURICE VIDAL PORTMAN, *Group of Andamanese men painted with Og and Tala-og*, ca. 1893
Platinum print, 28.4 × 35.3 cm
British Library OIOC Photo 188/7 (30)

77 MAURICE VIDAL PORTMAN and SURGEON WILLIAM
MOLESWORTH, *Anthropometrical measurements
and data of an Andamanese woman of the
Keda tribe*, 26th May 1894
Letterpress forms and mss
British Library OIOC Photo 188/13

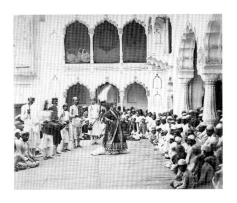

78 CHARLES SHEPHERD, *Nautch at Delhi*, ca. 1862
Albumen print, 23.2 × 28.5 cm
Howard and Jane Ricketts Collection

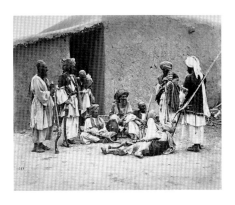

79 SHEPHERD & ROBERTSON, *Group of natives from
near the Khyber Pass*, ca. 1862
Albumen print, 22.6 × 29.1 cm
Bourne & Shepherd catalogue no. 1388
Howard and Jane Ricketts Collection

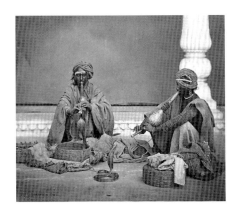

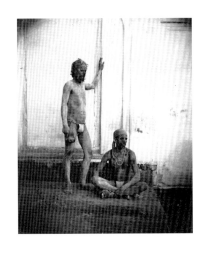

80 SHEPHERD & ROBERTSON, *Snake Charmers*,
ca. 1862
Albumen print, 18 × 20.9 cm
Bourne & Shepherd catalogue no. 1123
Howard and Jane Ricketts Collection

81* SHEPHERD & ROBERTSON, *Fakirs*, ca. 1862
Albumen print, 19.5 × 16.3 cm
Bourne & Shepherd catalogue no. 1127
Howard and Jane Ricketts Collection

82 SHEPHERD & ROBERTSON, *Acrobats*, ca. 1862
Albumen print, 23.6 × 19.1 cm
Bourne & Shepherd catalogue no. 1101
Howard and Jane Ricketts Collection

The Rebellion of 1857-1858

 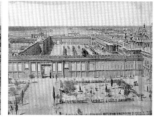

83* FELICE BEATO, *Old Observatory near Delhi*, 1858

Albumen print, 29.7 × 25.9 cm

No. 43 in the Beato catalogue of Delhi views issued by Henry Hering

Howard and Jane Ricketts Collection

84 FELICE BEATO, *Panorama of Lucknow, taken from the Kaiser Bagh Palace*, 1858

Albumen prints (six prints), 22.8 × 178.3 cm

Panorama A in the Beato catalogue of Lucknow and Cawnpore views issued by Henry Hering

British Library OIOC Photo 1087

Purchased with the assistance of The Friends of The British Library

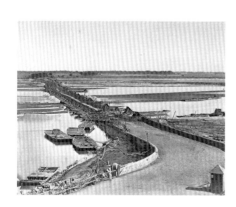

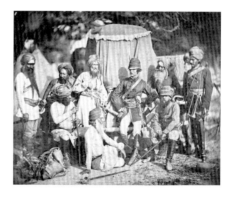

85 FELICE BEATO, *Bridge of Boats over the Jumna River, Delhi, taken from Salimgarh*, 1858

Albumen print, 25.4 × 29.8 cm

No. 1 in the Beato catalogue of Delhi views issued by Henry Hering

Howard and Jane Ricketts Collection

86* FELICE BEATO, *Clifford Henry Mecham and Dr Thomas Anderson with a group of Hodson's Horse*, 1858

Albumen print, 23.6 × 28.5 cm

Howard and Jane Ricketts Collection

87 ROBERT TYTLER and CHARLES SHEPHERD, *Bahadur Shah II, the ex-King of Delhi*, May 1858

Albumen print, 10.5 × 13.4 cm

British Library OIOC Photo 797 (37)

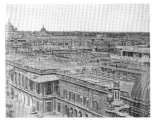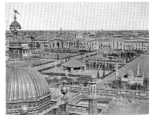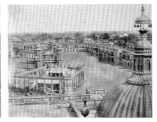

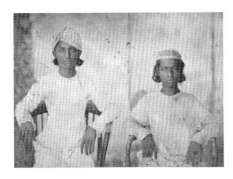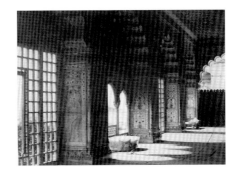

88 ROBERT TYTLER and CHARLES SHEPHERD, *King of Delhi's two sons. The interesting youth Jewan Bukt on the left of the picture* [Delhi], 1858

Albumen print, 10.5 × 14.5 cm

Howard and Jane Ricketts Collection

89★ CHARLES MORAVIA, *The crystal throne in the Diwan-i-Khas, Delhi*, 1858

Albumen print from a paper negative, 26.2 × 35.7 cm

Howard and Jane Ricketts Collection

In Search of the Picturesque

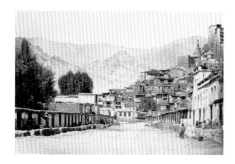

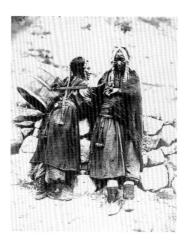

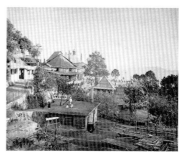

90* CAPTAIN MELVILLE CLARK, *The city of Le, the capital of Ladac,* 1862

Albumen print, 16.1 × 24.5 cm

Plate 17 of Captain Melville Clark, *From Simla through Ladac and Cashmere* (Calcutta, 1862).

British Library OIOC Photo 976 (17)

91 PHILIP HENRY EGERTON, *Married women of Spiti,* July 1863

Albumen print, 20.5 × 16.8 cm

Plate 26 of Philip Henry Egerton, *Journal of a tour through Spiti, to the frontier of Chinese Thibet, with photographic illustrations* (London, 1864).

British Library OIOC Photo 977 (26)

92 SAMUEL BOURNE, *The Lawrence Military Asylum, Sanawar, looking towards the playground from the church,* 1864

Albumen print, 23.9 × 29.3 cm

Bourne & Shepherd catalogue no. 1138

Howard and Jane Ricketts Collection

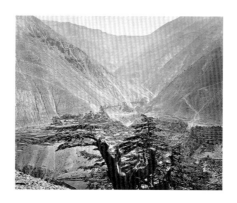

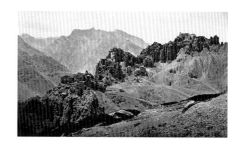

93* SAMUEL BOURNE, *The Lawrence Military Asylum, Sanawar, girls at play in front of the school,* 1864

Albumen print, 23.7 × 29.3 cm

Bourne & Shepherd catalogue no. 1141

Howard and Jane Ricketts Collection

94 SAMUEL BOURNE, *The village of Sungnam with the Hungrung Pass above,* 1866

Albumen print, 24 × 28.6 cm

Bourne & Shepherd catalogue no. 1475

Howard and Jane Ricketts Collection

95 SAMUEL BOURNE, *The picturesque village of Dunkar, Spiti,* 1866

Albumen print, 19.2 × 32 cm

Bourne & Shepherd catalogue no. 1461

Howard and Jane Ricketts Collection

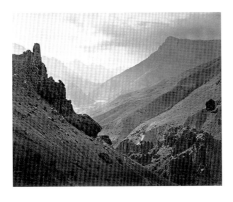

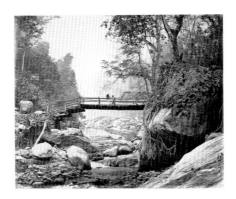

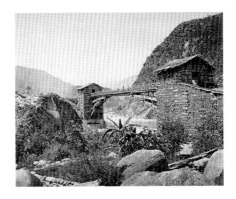

96 SAMUEL BOURNE, *The Spiti Valley from Dunkar –
evening, 1866*
Albumen print, 23.3 × 29.3 cm
Bourne & Shepherd catalogue no. 1465
Howard and Jane Ricketts Collection

97* SAMUEL BOURNE, *Picturesque bridge over the
Rungnoo below Ging, Darjeeling, ca. 1869*
Albumen print, 23.8 × 29.5 cm
Bourne & Shepherd catalogue no. 1900
Howard and Jane Ricketts Collection

98 SAMUEL BOURNE, *Bridge on the Ravi, Chumba,
from the south-east, 1864*
Albumen print, 24.3 × 29.3 cm
Bourne & Shepherd catalogue no. 549
Howard and Jane Ricketts Collection

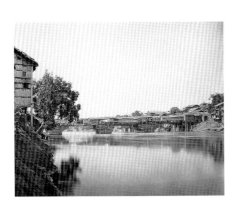

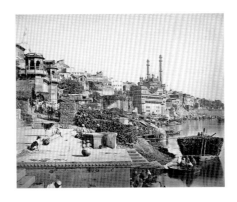

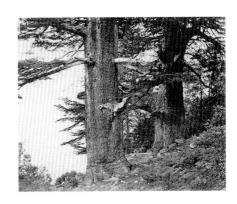

99 SAMUEL BOURNE, *Bridge of shops, Srinagar,
1864*
Albumen print, 23.8 × 29 cm
Bourne & Shepherd catalogue no. 788
Howard and Jane Ricketts Collection

100 SAMUEL BOURNE, *Ghats at Benares, 1864*
Albumen print, 23.4 × 29.4 cm
Bourne & Shepherd catalogue no. 1168
Howard and Jane Ricketts Collection

101 SAMUEL BOURNE, *Deodars, 1863*
Albumen print, 24.4 × 29.6 cm
Bourne & Shepherd catalogue no. 212
Howard and Jane Ricketts Collection

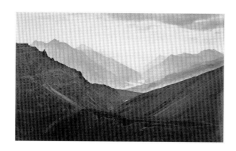

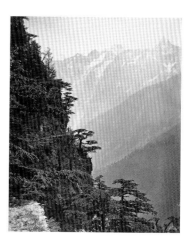

102* SAMUEL BOURNE, *Evening on the mountains – view from below the Manirung Pass*, 1866
Albumen print, 19.2 × 31.6 cm
Bourne & Shepherd catalogue no. 1467
Howard and Jane Ricketts Collection

103 SAMUEL BOURNE, *Small waterfall above Prini, Kulu*, 1866
Albumen print, 24.1 × 29.3 cm
Bourne & Shepherd catalogue no. 1440
Howard and Jane Ricketts Collection

104* SAMUEL BOURNE, *A 'bit' on the new road near Rogi*, 1866
Albumen print, 29.5 × 24.1 cm
Bourne & Shepherd catalogue no. 1506b
Howard and Jane Ricketts Collection

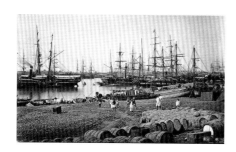

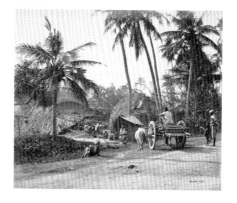

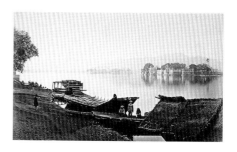

105 SAMUEL BOURNE, *Landing goods near the Customs House, Calcutta, ca.* 1867
Albumen print, 20 × 31.3 cm
Bourne & Shepherd catalogue no. 1726
British Library OIOC Photo 11 (37)

106* SAMUEL BOURNE, *Village life in Bengal, ca.* 1867
Albumen print, 23.7 × 28.4 cm
Bourne & Shepherd catalogue no. 1732
Howard and Jane Ricketts Collection

107 COLIN MURRAY for BOURNE & SHEPHERD, *The Water Palaces at Udaipur*, 1872–1873
Albumen print, 18.9 × 31.7 cm
Bourne & Shepherd catalogue no. 2278
Howard and Jane Ricketts Collection

108 DONALD HORNE MACFARLANE, *Forest Scene, Bengal, First Prize 1862*

Albumen print, 26.4 × 35.2 cm

Howard and Jane Ricketts Collection

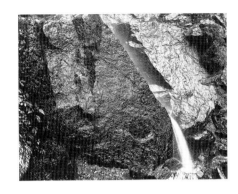

109★ DONALD HORNE MACFARLANE, *Rocks, Darjeeling, ca. 1862*

Albumen print, 22.9 × 29.2 cm

Howard and Jane Ricketts Collection

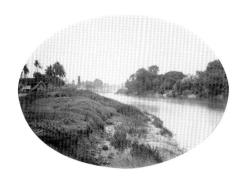

110★ DONALD HORNE MACFARLANE, *Tolly's Nullah, Calcutta, ca. 1860–1863*

Albumen print, 24.5 × 34.2 cm

Howard and Jane Ricketts Collection

111 DONALD HORNE MACFARLANE, *Tamarind and Creepers, ca. 1862*

Albumen print, 27.5 × 35.2 cm

Howard and Jane Ricketts Collection

Lala Deen Dayal

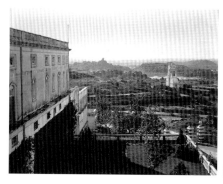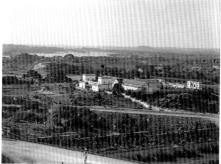

112 LALA DEEN DAYAL, *Panoramic view from the
Falaknuma Palace, Hyderabad, ca. 1890–1895*

Albumen prints, 19.7 × 51 cm

British Library OIOC Photo 761/1 (210)

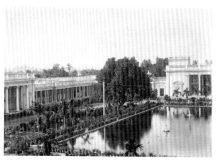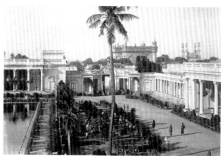

113 LALA DEEN DAYAL, *H.H. The Nizam's
Chowmahalla Palace, Hyderabad, ca. 1884–1888*

Albumen prints, 18.4 × 52.8 cm

British Library OIOC Photo 430/6 (2)

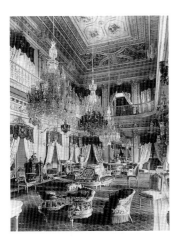

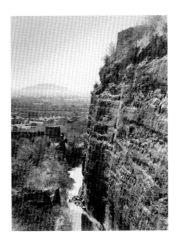

114 LALA DEEN DAYAL, *Interior of the Chowmahalla Palace, Hyderabad, ca.* 1884–1888
Albumen print, 26.2 × 20.4 cm
Howard and Jane Ricketts Collection

115* LALA DEEN DAYAL, *East scarp of Daulatabad Fort, ca.* 1884–1888
Albumen print, 26.7 × 19.9 cm
Howard and Jane Ricketts Collection

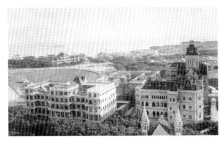

116 LALA DEEN DAYAL, *Panoramic view of Bombay from the Rajabai Tower, ca.* 1890
Printing-out paper, 15.2 × 51.8 cm
British Library OIOC Photo 784/1 (35)

Princes and Pageants

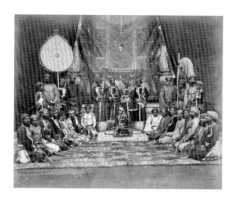

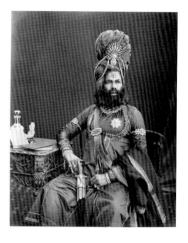

117* SHEPHERD & ROBERTSON, *Durbar at Bharatpur*, 1862

Albumen print, 22.7 × 27.9 cm

British Library OIOC Photo 793 (63)

118* DAROGAH HAJI ABBAS ALI, *Portraits of the Rajas and Taluqdars of Oudh, ca.* 1880

Albumen prints, each 8.4 × 5.2 cm

Four tipped-in *carte de visite* prints from Darogah Haji Abbas Ali, *An illustrated historical album of the Rajas and Taaluqdars of Oudh* (Allahabad, 1880)

British Library OIOC Photo 987

119 UNKNOWN PHOTOGRAPHER, *Rudra Pratap Singh, Maharaja of Panna*, 1880s

Albumen print, 29.4 × 23.6 cm

British Library OIOC Photo 209 (11)

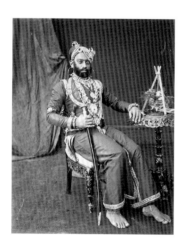

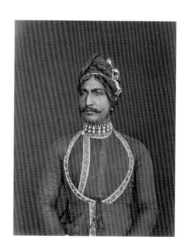

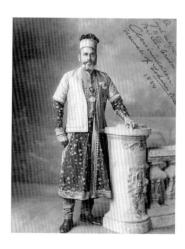

120 UNKNOWN PHOTOGRAPHER, *Sir Sujan Singh, Maharana of Udaipur*, 1880s

Albumen print, 27.5 × 22.8 cm

British Library OIOC Photo 209 (9)

121 UNKNOWN PHOTOGRAPHER, *Sir Mangal Singh, Maharaja of Alwar*, 1880s

Albumen print, 27.1 × 21.2 cm

British Library OIOC Photo 209 (10)

122 G.W. LAWRIE & CO., *Sir Amir-ud-din Ahmad Khan, Nawab of Loharu*, 1884

Albumen print, 27.8 × 22.6 cm

British Library OIOC Photo 100 (39)

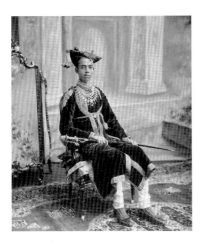 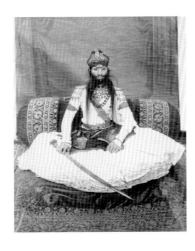

123 BOURNE & SHEPHERD, *Sir Udaji Rao Ponwar,*
 Maharaja of Dhar, ca. 1900
 Albumen print, 27.2 × 23.6 cm
 British Library OIOC Photo 99 (3)

124* GANPATRAO ABAJEE KALE, *Sir Raghubir Singh,*
 Maharao of Bundi, ca. 1900
 Printing-out paper, 27.4 × 23 cm
 British Library OIOC Photo 100 (26)

 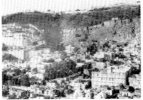 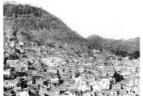 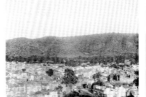 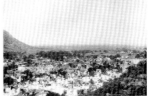

125 HERZOG & HIGGINS, *Panorama of Bundi,* 1902
 Collodion printing-out paper, 21.3 × 144.6 cm
 British Library OIOC Photo 430/20 (49)

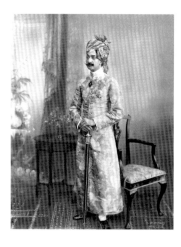

126 HERZOG & HIGGINS, *Sir Madan Singh, Maharaja*
 of Kishangarh, ca. 1911
 Hand-coloured print, 62 × 48 cm
 British Library OIOC Photo 100 (48)

127 HERZOG & HIGGINS, *Panoramic view of Abu*
 looking north from Jaipur House, ca. 1902
 Collodion printing-out paper, 19.5 × 54.8 cm
 British Library OIOC Photo 430/20 (102)

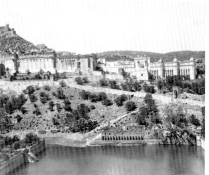

128 HERZOG & HIGGINS, *Panoramic view of Amber*
 Palaces and Fort, ca. 1902
 Collodion printing-out paper, 23.2 × 54.7 cm
 British Library OIOC Photo 430/20 (188)

129* BOURNE & SHEPHERD, *The amphitheatre at the*
 Imperial Assemblage, Delhi, 1877
 Albumen print, 18.4 × 31.7 cm
 British Library OIOC Mss Eur F111/276 (6)

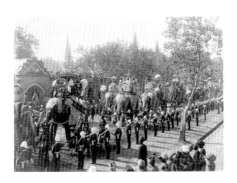

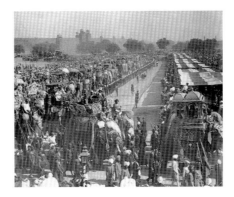

130 THOMAS A. RUST, *The Delhi Durbar: procession of the ruling chiefs*, 29 December 1902

Printing-out paper, 21.4 × 29.7 cm

British Library OIOC Mss Eur FIII/270 (12)

131 S.H. DAGG, *The Delhi Durbar: procession of Indian Rulers approaching the Jami Masjid*, 29 December 1902

Printing-out paper, 20.2 × 28.2 cm

British Library OIOC Mss Eur FIII/270 (19)

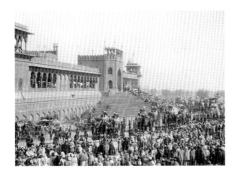

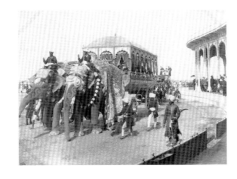

132* WIELE & KLEIN, *The Delhi Durbar: elephant procession of the Viceroy's staff passing the Jami Masjid*, 29 December 1902

Printing-out paper, 20.2 × 28.2 cm

British Library OIOC Mss Eur FIII/270 (33)

133 HERZOG & HIGGINS, *The Delhi Durbar: elephant carriage of the Maharaja of Rewa at the Retainers' Review*, 7 January 1903

Printing-out paper, 20.5 × 28.4 cm

British Library OIOC Mss Eur FIII/270 (163b)

Railways and Public Works

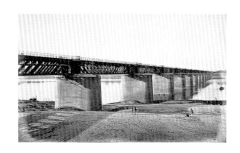

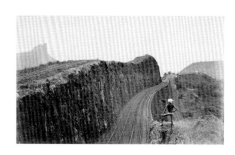

134 SAMUEL BOURNE, *The railway bridge across the Jumna at Allahabad,* 1864
Albumen print, 19 × 31.7 cm
Bourne & Shepherd catalogue no. 1200
Howard and Jane Ricketts Collection

135* BOURNE & SHEPHERD, *Reversing station on the Bhore Ghat Incline, ca.* 1870
Albumen print, 18.7 × 31.2 cm
Howard and Jane Ricketts Collection

136 BOURNE & SHEPHERD, *The loop at 'Agony Point' at Tindharia on the Darjeeling Hill Railway,* 1880s
Albumen print, 23.7 × 28.3 cm
British Library OIOC Photo 576 (48)

137* UNKNOWN PHOTOGRAPHER, *Locomotive 'Akbar' being ferried across the Jumna during construction of the railway bridge at Kalpi,* 14 January 1887
Albumen print, 19.9 × 28.3 cm
British Library OIOC Photo 1084/2 (18)

138* J.C. TOWNSHEND, *Weingunga Bridge, conversion from metre to broad gauge, ca.* 1890
Albumen print, 20.4 × 27.4 cm
Howard and Jane Ricketts Collection

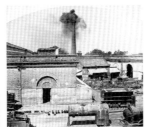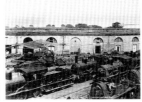

139 UNKNOWN PHOTOGRAPHER, *East Indian Railway Company workshops, Jamalpur, 1896*

Printing-out paper, 25 × 137.8 cm

British Library OIOC Photo 15/8 (1)

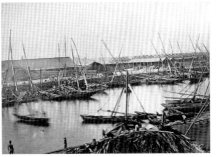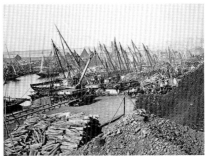

140 FRITZ KAPP, *Munshai Bridge on the East Bengal State Railway after the earthquake, 1897*

Albumen print, 27.7 × 23.2 cm

Howard and Jane Ricketts Collection

141 UNKNOWN PHOTOGRAPHER, *Panoramic view of the Elphinstone Reclamation, Bombay, early 1860s*

Albumen prints, 20.3 × 54.5 cm

British Library OIOC Photo 697 (7)

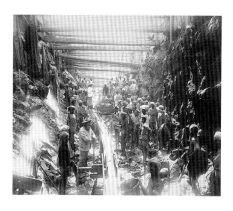

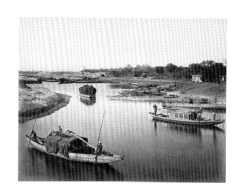

142 E. TAURINES, *Trench of east wall cut through*
 rock looking south, Bombay Docks Extension,
 19 December 1885
 Albumen print, 24.8 × 29.3 cm
 British Library OIOC Photo 173 (13)

143* UNKNOWN PHOTOGRAPHER, *Scene on the Madras*
 Canal, 1860s
 Albumen print, 21 × 27.3 cm
 Howard and Jane Ricketts Collection

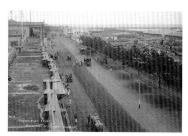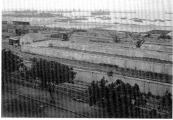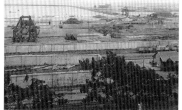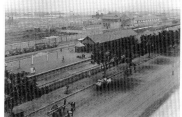

144 UNKNOWN PHOTOGRAPHER, *Panoramic view of*
 Madras Harbour, 1906
 Matt collodion printing-out paper, 22.2 × 113 cm
 British Library OIOC Photo 384 (4)

The Indian Scene

145* UNKNOWN PHOTOGRAPHER, *Mussocks for crossing the River Beas*, 1860s

Albumen print, 16.1 × 21.2 cm

Howard and Jane Ricketts Collection

146* UNKNOWN PHOTOGRAPHER, *Man drawing water at a well*, 1860s

Albumen print, 20.9 × 27 cm

Howard and Jane Ricketts Collection

147 UNKNOWN PHOTOGRAPHER, *The New Observatory, Dehra Dun*, 1860s

Albumen print, 21.1 × 27.8 cm

Howard and Jane Ricketts Collection

148* J.F. PEARSON (attrib.), *Ship aground after the Calcutta Cyclone*, 1864

Albumen print, 18 × 23 cm

Howard and Jane Ricketts Collection

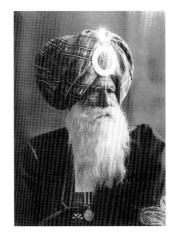

149 JOHN BURKE, *Major Nihal Singh, 45th Rattray's Sikhs*, ca. 1880

Albumen print, 28.9 × 21.3 cm

Howard and Jane Ricketts Collection

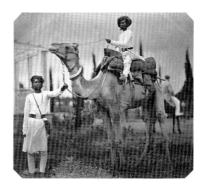

150* UNKNOWN PHOTOGRAPHER, *Sowaree camels*, early 1860s

Albumen print, 22.8 × 25.7 cm

Howard and Jane Ricketts Collection

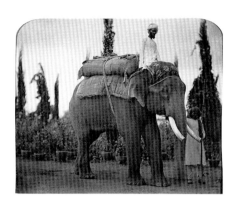

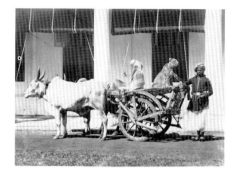

151 UNKNOWN PHOTOGRAPHER, *Government House Elephants, Poona*, early 1860s
Albumen print, 22.1 × 27 cm
Howard and Jane Ricketts Collection

152* UNKNOWN PHOTOGRAPHER, *Lady Louisa Bruce, daughter of the Viceroy Lord Elgin, with her tame deer and in her janpan, Simla*, 1863
Albumen prints, 11.5 × 9.4 and 12.2 × 17 cm
Photograph A shown here
Howard and Jane Ricketts Collection

153* UNKNOWN PHOTOGRAPHER, *Rajah of Vallur with hunting cheetahs and country cart and with tame deer and carriage presented to the Prince of Wales*, 1875
Albumen prints, 15.8 × 21.6 cm
Photograph A shown here
Howard and Jane Ricketts Collection

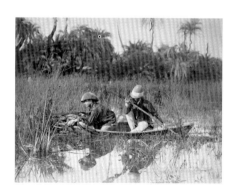

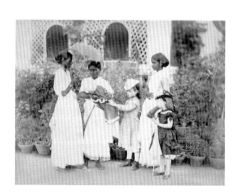

154 UNKNOWN PHOTOGRAPHER, *Crocodiles at Magar Pir, near Karachi*, early 1860s
Albumen print, 20.2 × 26.2 cm
Howard and Jane Ricketts Collection

155* WILLOUGHBY WALLACE HOOPER, *Duck shooting*, early 1870s
Albumen print, 17.6 × 22.9 cm
Howard and Jane Ricketts Collection

156* WILLOUGHBY WALLACE HOOPER (attrib.), *Ayahs with English children*, 1880s
Albumen print, 18.9 × 24.4 cm
Howard and Jane Ricketts Collection

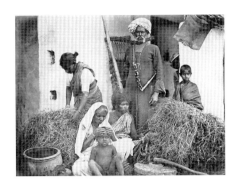

157　WILLOUGHBY WALLACE HOOPER, *Indian trades: Grasscutters, Dyers, Carpenters, Gardeners*, 1870s

Albumen prints, 14.5 × 19.3 cm, 14.5 × 19.5 cm, 14.6 × 19.5 cm, 15.6 × 20.1 cm

Photograph A shown here

Howard and Jane Ricketts Collection

158★ CAPTAIN FREDERICK KILGOUR, *View from the interior of the Judge's House, Madura*, 1874–1876

Albumen print, 22.1 × 28.9 cm

Howard and Jane Ricketts Collection

159　UNKNOWN PHOTOGRAPHER, *Verandah of a bungalow*, 1870s

Albumen print, 22.4 × 29.1 cm

Howard and Jane Ricketts Collection

160★ ROBERT PHILLIPS, *Cane bridge on the River Tista, Darjeeling*, early 1870s

Albumen print, 19.4 × 24 cm

Howard and Jane Ricketts Collection

Cameras and Chemicals

161 Ross & Co, *Mahogany and brass 10 × 12 inch folding tailgate camera with Goertz 20 inch lens, 1880s*
Michael Gray

162 F. Fisk Williams, *A Guide for the Indian Photographer* (R.C. Lepage & Co., Calcutta, 1860)
British Library 1267.c.19

163 John Blees, *Photography in Hindostan; or Reminiscences of a Travelling Photographer* (Bombay, 1877)
British Library 8908.a.14

164 *List of photographic apparatus and chemicals used by Linnaeus Tripe*
Fort St George Public Consultations of 18 August 1857, pp. 384–85.
British Library OIOC India Office Records P/249/63

165 Linnaeus Tripe, *On a Photographic Printing Process*
Madras Journal of Literature and Science, new series no. 2, Jan-Mar 1857, pp. 166–67
British Library Ac.8829

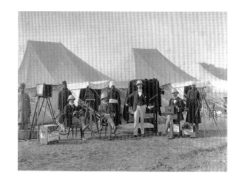

166* Bourne & Shepherd, *Bourne & Shepherd photographers with their equipment at the Delhi Durbar, 1902–1903*
Platinum print, 21.4 × 28.8 cm
British Library OIOC Photo 440/2 (45)

167 Lala Deen Dayal, *Raja Sir Pratap Singh of Orchha, at Tikamgarh, 1882*
Dry-plate glass negative, 29.8 × 25.1 cm
British Library OIOC Photo 1000/16 (1658)

168 Lala Deen Dayal, *Raja Sir Pratap Singh of Orchha, at Tikamgarh, 1882*
Modern printing-out paper print by John Falconer from original negative, 29.7 × 25 cm
From British Library OIOC Photo 1000/16 (1658 neg)

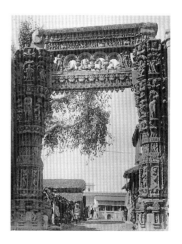

169 Lala Deen Dayal, *Ancient gateway at Rewa, 1882*
Albumen print, 26.9 × 20.5 cm
British Library OIOC Photo 50/2 (148)

Biographical Index of Photographers

Abbas Ali, Darogah [fl. 1870s]

Amateur. Municipal engineer in Lucknow in the 1870s, who produced two photographically-illustrated books: *The Lucknow album* (Calcutta, 1874), a guide book containing 50 albumen prints, and the *Illustrated historical album of the Rajas and Taaluqdars of Oudh* (Allahabad, 1880), with 250 carte-de-visite prints.

Ali Khan, Darogah **Ahmad** [fl. 1850s–1860s]

Commercial. Also known as Chota Meer. In 1856 he produced an extensive and historically important series of portraits of the Indian and European residents of Lucknow. He became a member of the Bengal Photographic Society in 1862.

Beato, Felice (Felix) [b. ca. 1825; d. ca. 1907]

Commercial. Italian-born photographer, in partnership with James Robertson in the Middle East 1853–1857. In India 1858–1859, where he photographed the aftermath of the Mutiny, particularly at Cawnpore, Lucknow and Delhi, and China 1860–1861, where he documented the Anglo-Chinese War. A catalogue of over 300 of his Indian and Chinese photographs was published by the London dealer Henry Hering. He later worked in Japan (1864–1885), Korea (1871), the Sudan (1886) and Burma (ca. 1889–ca. 1906).

Biggs, Colonel Thomas [b. Herts 27 Apr 1822; d. Somerset, 13 Feb 1905]

Amateur. Indian Army, entered Bombay Artillery 1842. Supplied with a camera by the East India Company in 1854 and appointed Government Photographer, Bombay, to record architectural and archaeological sites from February to December 1855, when he was recalled to military duties. He was succeeded as Government Photographer by W.H. Pigou (qv). In the early 1860s he took a further set of architectural views at Ahmadabad. Photographs by Biggs appear in Philip Meadows Taylor and James Fergusson's *Architecture in Dharwar and Mysore* (London, 1866) and *Architecture at Beejapoor* (London, 1866), and in T.C. Hope and J. Fergusson, *Architecture at Ahmedabad* (London, 1866).

Blees, John. [fl. 1870s–1890s]

Commercial. Took up photography in about 1873 and managed a studio at Jabalpur from 1882–1899, with additional studios at Calcutta (1887–ca. 1933) and Lahore (1893–1898). He was the author of an instructional manual aimed at the amateur photographer, *Photography in Hindostan; or reminiscences of a travelling photographer* (Bombay, 1877). Blees himself probably left India in the 1890s.

Bourne, Samuel [b. Staffs., 30 Oct 1834; d. Nottingham, 24 Apr 1912]

Commercial. A bank clerk and amateur photographer in Nottingham in the 1850s, Bourne arrived in India in January 1863, where the firm of Howard, Bourne and Shepherd was established in Simla. By 1865 the business had become Bourne and Shepherd and additional studios were established in Calcutta (1867) and Bombay (1870). Bourne made three celebrated photographic expeditions to Kashmir and the Himalayas between 1863 and 1866, which he described at length in a series of letters published in *The British Journal of Photography*. He finally left India in 1870, although the firm of Bourne and Shepherd continues to the present day.

Bourne & Shepherd: *see* Bourne, Samuel

Burke, John [b. 1843; d. Lahore, 27 May 1900]

Commercial. Burke was active as a photographer from 1861, with studios at Murree and Peshawar, and was hired to take the photographs which appear in H.H. Cole's *Illustrations of ancient buildings in Kashmir* (London, 1869). Between 1871 and 1880 he worked with William Baker in the partnership of Baker and Burke and in 1878–1879, as official photographer to the army made an important record of the Second Afghan War. In 1885 he opened a studio in Lahore, which continued trading until 1903. His son William ('Willie'), born in 1861, was employed in his father's firm and later (ca. 1910) opened his own studios in Madras and Ootacamund.

Clarke, Melville [b. 15 Dec 1834; d. 1 Feb 1878]

Amateur. Indian Army, served with Bengal Cavalry from 1852 and from 1858 with the 1st Bengal European Light Cavalry. He contributed photographs to *The People of India* (8 vols, 1868–1875) and a number of his views of Kashmir were shown to and commended by the Bengal Photographic Society in April 1862. These were probably among the 37 photographs used to illustrate the account of his travels published as *From Simla through Ladac and Cashmere, 1861* (Calcutta, 1862).

Cousens, Henry [b. 13 Sep 1854; d. Tunbridge Wells, 1933]

Amateur. Archaeological Survey 1875–1910; he became Archaeological Surveyor, Western India, in 1890 rising to Superintendent of the Western Circle. He used photography extensively from the 1880s to record his archaeological tours and in 1900 made a

detailed photographic survey of the sculptures of the stupa at Sanchi. His photographs are also used to his illustrate his architectural writings, among them, *Bijapur and its architectural remains* (Bombay, 1916) and *The Chalukyan architecture of the Kanarese districts* (Calcutta, 1926)

Croker, William [b. 1825; d. 1871]

Amateur. Served in the British Army in India 1845–1868, with interests in tea estates in the Kangra Valley. His papers in the British Library (OIOC Mss Eur E421) contain a number of his amateur photographic attempts as well as a notebook, entitled *Notes on Photographic Trials...April 1859–*.

Dagg, S.H. [fl. 1890s]

Commercial. With studios in Mussoorie and Allahabad in the 1890s. Working for Lawrie & Co., Lucknow, ca. 1895.

Deb Barmar, Shamarandra Chandra [fl. 1890s]

Amateur. Son of Maharaja Birchandra Manikya of Tripura, and a noted exponent of platinum printing in the 1890s. Exhibited widely in both India and various British camera societies. At the 1893 exhibition of the Midland Camera Club, he exhibited 17 photographs, winning a silver medal in the landscape category and a bronze in the portrait section.

Deen Dayal, Lala [b. 1844; d. 1905]

Commercial. Trained as a draughtsman at the Thomason Engineering College at Roorkee, and in the early 1880s was employed as an estimator in the Public Works Department at Indore. He took up photography in the 1870s, but was still styling himself 'amateur photographer' in 1883, although in the previous year he had accompanied Sir Lepel Griffin as photographer on an architectural tour of Central India, the results of which were published in Griffin's *Famous monuments of Central India* (London, 1886). In 1884 he became official photographer to the Nizam of Hyderabad, with studios in Secunderabad and Indore and in 1885 was appointed official photographer to the Viceroy Lord Dufferin. A Bombay studio opened about 1886 and in 1892 he announced 'the opening of a zenana photographic studio he has fitted up at Hyderabad'.

Egerton, Philip Henry [b. 9 Aug 1824]

Amateur. Arrived in India as a writer, 1843 and served as Assistant to Commissioner of Revenue, Delhi; Magistrate and Collector, Delhi, 1855; Deputy Commissioner, Delhi 1858, Kangra 1861; Commissioner of Hissar 1866, Amritsar 1870; retired 1872. A keen amateur photographer in the 1860s, his *Journal of a tour through Spiti to the frontier of Chinese Tibet* (London, 1864) contains 37 tipped-in albumen prints, among them the first photographs of the Spiti Glacier.

Fiebig, Frederick [fl. 1840s–1850s]

Amateur (?). Of German origin, Fiebig was originally a lithographer in Calcutta in the 1840s, producing topographical views; in 1846 he visited Singapore for the purpose of painting a now lost panoramic view of the settlement and in 1847 published a lithographic panoramic view of Calcutta taken from the top of the Ochterlony Monument. Took up photography in about 1849 and in the following three years produced an extensive series of views of Calcutta and Madras, which together with additional photographs of Sri Lanka, Mauritius and Cape Town were purchased as hand-coloured salt prints by the East India Company in 1856.

Gill, Robert [b. London 26 Sep 1804; d. Ajanta 10 Apr 1875]

Amateur. Entered Madras Army 1824. In 1844 Gill was seconded to make painted copies of the paintings in the Ajanta Caves, a task which occupied him for some twelve years (almost all these paintings were later destroyed in the Crystal Palace fire of 1866). Gill took up photography in the 1850s and in the 1860s produced a photographic record of the Ajanta Caves, their frescoes and other archaeological sites in Western India. A number of these stereoscopic views were published in two books by James Fergusson, *The rock-cut temples of India* (London, 1864, 76 prints) and *One hundred stereoscopic illustrations of architecture and natural history in Western India* (London, 1864).

Henderson, William [fl. 1840s–1860s]

Commercial. Clerk in the Uncovenanted Bombay Civil Service ca. 1840–1844 and an employee of Peel, Cassels & Co. from ca. 1845–1856, Henderson was from 1856 an early member of the Bombay Photographic Society; in 1858 he entered into a short-lived professional photographic partnership with William Johnson (qv) and from 1859 until the end of the 1860s the studio of Henderson and Co was trading in Bombay, although

Henderson himself appears to have left India in about 1857.

Herzog & Higgins [fl. 1890s–1920s]

Commercial. The most successful studio in the cantonment town of Mhow, where they operated a studio from about 1894–1921. P.A. Herzog had worked as an assistant to John Blees (qv) in Jabalpur in the late 1880s, and both Herzog and P. Higgins were assistants to Lala Deen Dayal (qv) and Johnston & Hoffmann in about 1890.

Hooper, Colonel Willoughby Wallace [b. London 19 May 1837; d. Kilmington 21 Apr 1912]

Amateur. Entered 7th Madras Cavalry 1858. A prolific amateur photographer from the early 1860s, Hooper was seconded from military duties from October 1861 to June 1862 to take a series of ethnographical photographs in the Central Provinces, a number of which later appeared in *The People of India* (8 vols, London, 1868–1875). In about 1872 he produced for sale in collaboration with George Western a series of views illustrating tiger hunting and in 1876–1878 photographed victims of the Madras Famine. As Provost-Marshal with the Burma Expeditionary Force of 1885–1886 he made a record of the campaign, published as an album entitled *Burmah: a series of one hundred photographs* and also as lantern slides. After the campaign he was officially censured for attempting to photograph a military execution at Mandalay.

Huish, Alfred [b. Clisthydon, Devon 1811]

Amateur. Bengal Artillery 1827–ca. 1854. An album of salt prints from paper negatives made by Huish between 1848 and 1852 are among the earliest surviving images from the subcontinent.

Impey, Eugene Clutterbuck [b. Paris 16 Aug 1830; d. Oxford Nov 1904]

Amateur. Entered 5th Bengal Cavalry 1851; Assistant Agent to the Governor General, Rajputana 1856; Political Agent at Alwar 1858; Military Secretary to the Viceroy Lord Lawrence 1863–1864; Resident, Nepal; retired 1878. A prolific and skilled photographer, Impey was a frequent contributor to exhibitions of the Bengal Photographic Society and a committee member in the mid-1860s. A collection of

his photographs was published in his *Delhi, Agra, and Rajpootana, illustrated by eighty photographs* (London, 1865).

Johnson, William [*fl.* 1840s–1860s]

Commercial. Clerk and assistant in the Uncovenanted Civil Service, Bombay 1848–1861. A founder member and secretary of the Bombay Photographic Society in 1854, he was editor of the society's journal. Johnson also ran a daguerreotype studio in Bombay from 1852–1854 and a photographic studio from about 1855 until the late 1860s, the latter briefly in partnership with William Henderson (*qv*). The pair collaborated on the production of *The Indian amateurs photographic album*, which ran for 36 issues between 1856–1858, each number containing three original prints. On his return to England he published the photographically illustrated *The oriental races and tribes, residents and visitors of Bombay* (2 vols, London, 1863–1865).

Kale, Gunpatrao Abajee [*fl.* 1880s–1900s]

Commercial. State photographer of Bundi, Rajasthan, 1880s–1900s.

Kapp, Fritz [*fl.* 1880s–1900s]

Commercial. Kapp had studios in Chowringhee Road and Humayun Place, Calcutta from about 1888–1903 and at Darjeeling. In the early 1900s he also maintained a studio in Wise Ghat Road, Dacca.

Kilgour, Frederick [*b.* 9 Apr 1841; *d.* 26 Mar 1919]

Amateur. Entered Madras Native Infantry 1857. Superintendent of Police, Madura, in the 1870s. In 1876 he published an album of 90 photographic views entitled *Scenery and life in the district of Madura (South India), 1874–1876*.

Lawrie & Co., G.W. [*fl.* 1880s]

Commercial. Worked in the photographic partnership of Saché & Lawrie at Naini Tal in 1881, before opening his own studio from 1883 to about 1921. From the mid-1880s to 1890s, a Lucknow studio was also maintained.

Lyon, Edmund David [*b.* 1825; *d.* Gmunden, Austria 14 Dec 1891]

Commercial. Served in British Army 1845–1854. Governor of Dublin District Military Prison 1854–1856. Worked as a professional photographer in India, with a studio in Ootacamund from 1865–1869; a series of

his views of the Nilgiris was shown at the Paris International Exhibition of 1867. From 1867–1868 he was commissioned by the Madras and subsequently the Bombay Governments to photograph archaeological and architectural antiquities, assisted by his wife Anne Grace Lyon. Lyon photographed in Malta on the way back to England in 1869 and in the late 1880s settled in the island. During this decade he also published two novels, *The signora* (1883) and *Ireland's dream: a romance of the future* (1888)

Macfarlane, Sir Donald Home [*b.* Caithness Jul 1830; *d.* London 2 Jun 1904]

Amateur. Macfarlane went to India in 1859 as a partner in the firm of Begg, Dunlop & Co and returned to Scotland in 1864. He was later M.P. for Co. Carlow (1880–1885) and Argyllshire (1885–1886 and 1892–1895). A prominent member of the Bengal Photographic Society from 1860, to whose meetings he presented a number of papers, and on which he served as President in 1863 and won a number of medals for his landscape photographs.

Moravia, Charles Barclay Woodham [*b.ca.* 1821; *d.* Sialkot 30 Apr 1859]

Amateur. Executive engineer, responsible for the demolition of buildings in Delhi after the Mutiny. Moravia was appointed Principal of the Engineering School at Lahore in 1859, but died of smallpox shortly after taking up the post. In 1858 he made a number of waxed paper views of architectural scenes in Delhi.

Murray, Colin Roderick [*b.* Lewis, Hebrides 25 Dec 1840; *d.* Calcutta 29 Dec 1884]

Commercial. Photographer in Jaipur from 1867–1870, Murray joined the firm of Bourne and Shepherd in 1871, and with the departure of Samuel Bourne became the firm's leading landscape photographer. In 1872–1873 he made a photographic tour whose results were published in James Burgess' *Photographs of architecture and scenery in Gujarat and Rajputana* (Bourne and Shepherd, Calcutta, 1874).

Murray, John [*b.* Nov 1809; *d.* Sherringham 27 Jul 1898]

Amateur. Indian Medical Service (Bengal) 1832–1871. Murray took up photography in the late 1840s and was perhaps the finest exponent of calotype photography in India in the 1850s. In the 1850s he served as Civil Surgeon at Agra and during this period made an extensive

series of large format studies of the Mughal architecture of the North-West Provinces. The London publisher Hogarth issued a portfolio of his topographical and architectural views under the title *Agra and its vicinity* (London. 1858) and a further series of photographs also appeared in J.T. Boileau's *Picturesque views in the N.W. Province of India* (London, 1859). Murray was also the author of a number of works on cholera and medical topography.

Newland, James William [*d.* Meerut 10 May 1857]

Commercial. A British subject, Newland was one of the earliest professional daguerreo-typists in Australia, opening short-lived studios in Hobart and Sydney in 1848, having previously photographed in South America and the Pacific. Newland came to Calcutta in about 1850, where he opened a successful daguerreotype and photographic studio. He was killed during the Indian Mutiny, although his studio survived under the management of his half-brother Frederick Welling until around 1860.

Pearson, J.F. [*fl.* 1860s]

Commercial. Employee of Petter & Co. Produced a series of fifty views entitled 'Records of the Cyclone' documenting the effects of the great storm of 1864 which devastated Calcutta, which were shown at the Bengal Photographic Society Exhibition of that year.

Penn, Albert Thomas Watson [*b.* 1849; *d.* Coonoor 19 Oct 1924]

Commercial. Penn opened a studio in Ootaca-mund in around 1875 and was for many years the most successful photographer in the hill station, producing topographical views of the Nilgiris and numerous portrait studies of hill tribes.

Phillips, Robert [*d.* 1882]

Commercial. Photographer and general merchant at Darjeeling, 1870–1880s. After Phillips' death the business was managed by his widow Mrs E. Phillips and an assistant H.C. Stevens. A number of views by Phillips were shown at the Bengal Photographic Society exhibition of 1872.

Pigou, William Harry [*b.* Jul 1818; *d.* Poona 10 Sep 1858]

Amateur. Indian Medical Service (Bombay) 1841–1858. Pigou succeeded Thomas Biggs

(*qv*) as Government Photographer, Bombay Presidency from 1855–1857. A number of his photographs appear in M. Taylor and J. Fergusson, *Architecture in Dharwar and Mysore* (London, 1866)

Portman, Maurice Vidal [*b.* Canada 21 Mar 1860; *d.* Axbridge 14 Feb 1935]

Amateur. Portman served in the Royal Indian Marine from 1876–1879, when he was appointed to the Andaman Islands in charge of Andaman Homes, where he served until his retirement in 1900. In 1889 Portman offered to make for the British Museum an extensive series of photographs of all aspects of Andamanese life and culture and in the course of the 1890s produced a series of volumes of photographs and anthropological data. He was also the author of *A history of our relations with the Andamanese* (2 vols, Calcutta, 1899).

Ricalton, James [*fl.* 1890s–1900s]

Commercial. Ricalton was employed by the American stereoscopic photograph publishers Underwood & Underwood and photographed for the firm in India, the Philippines and China. He was also the author of the volume accompanying his Indian views, *India through the stereoscope. A voyage through Hindustan* (New York, *ca.* 1903), in which the publishers note that 'Mr Ricalton has personally made several long visits to India, traveling all over the country from north to south and from west to east. He probably knows the land and its life more intimately than any other American traveler.'

Rowe, Josiah [*b. ca.* 1809; *d.* Calcutta 7 Oct 1874]

Amateur. A builder and surveyor in Calcutta from the mid-1830s and later drawing master at the Presidency College, Rowe was one of the earliest amateur photographers in Calcutta and was an enthusiastic daguerreotypist in the 1840s. In the early 1860s he produced a series of portraits of Calcutta worthies and in 1862 served on the committee of the Bengal Photographic Society.

Rust, Thomas A. and Julian [*fl.* 1860s–1910s]

Commercial. Thomas Rust started his photographic career in about 1869 as assistant to F.W. Baker & Co. in Calcutta, and was running the Calcutta Photographic Company with W.T. Burgess from 1870–1873. From about 1874 he was managing his own studios in Allahabad,

Mussoorie, Murree, Landour and Meerut. His son Julian joined the firm in about 1899, and managed it until shortly before the First World War.

Scott, Captain Allan Newton [*b.* Forfar 20 Apr 1824; *d.* London 5 Jan 1870]

Amateur. Madras Artillery 1840–1866. An early member of the Madras Photographic Society in the 1850s and a frequent exhibitor, a number of his photographs were also displayed at the London International Exhibition of 1862. His stereograms won the first prize at the Madras Photographic Society Exhibition of 1861, and 100 of these were later published in his *Sketches in India; taken at Hyderabad and Secunderabad* (London, 1862).

Shepherd, Charles: *see* **Shepherd & Robertson**

Shepherd & Robertson [*fl.* 1860s]

Commercial. Charles Shepherd is known to have been commercially active as a photographer from at least 1858, when he collaborated with Robert Tytler (*qv*) in taking a portrait of Bahadur Shah, the ex-King of Delhi. The partnership of Shepherd and Robertson lasted only from about 1862–1863, with studios first at Agra and then Simla. During this period the partners created an extensive collection of topographical and ethnographical studies of Northern India. In 1863 the partnership was dissolved when Shepherd moved to Simla to join Samuel Bourne in the firm of Bourne & Shepherd. A number of Shepherd & Robertson's studies of racial types became part of the Bourne and Shepherd catalogue. Shepherd appears to have left India by about 1878.

Simpson, Sir Benjamin [*b.* Ireland 31 Mar 1831; *d.* London 27 Jun 1923]

Amateur. Indian Medical Service (Bengal) 1853–1890. Surgeon-General, Government of India 1885–1890. A series of 80 portraits of racial types of northern India was shown and awarded a gold medal at the London International Exhibition of 1862, and a further trip to Assam in 1867–1868 yielded further portraits, which were reproduced in Edward Tuite Dalton's *Descriptive ethnology of Bengal* (Calcutta, 1872). Many of these studies were also used in John Forbe Watson and John William Kaye's *The People of India* (8 vols, London, 1868–1875). Simpson served as Vice-President of the Bengal Photographic Society in 1862 and won a

number of medals at society exhibitions in the early 1860s. He later produced a series of views of Kandahar during the Second Afghan War of 1879–1880, which were marketed by Bourne & Shepherd.

Stanley, Captain John Constantine [*b.* 1837; *d.* 1878]

Amateur. Grenadier Guards; ADC to Lord Canning in 1858. An important album of portraits compiled by Stanley during his period as Canning's ADC contains a number of his own amateur photographic efforts.

Tanner, Colonel Henry Charles Baskerville [*b.* Tasmania 1835; *d.* 1898]

Amateur. Entered Bombay Artillery 1854, but transferred to the Survey of India in 1862, in which he served for the remainder of his career. In 1861 he produced for the Bombay Government a series of portraits of racial types of Sind. A number of these appear in Watson and Kaye's *The People of India* (8 vols, London, 1868–1875). He was also an amateur artist of note.

Taurines, E. [*fl.* 1880s–1900s]

Commercial. Taurines ran a studio in Bombay from 1885 until *ca.* 1902, around which time he appears to have left India. In the mid-1880s he made an extensive documentation of the construction of the Victoria Dock, Bombay and was briefly in partnership with Charles Nicond as Taurines, Nicond & Co. from 1891–1892.

Taylor, Captain Clarence Comyn [*b.* Vellore 5 Nov 1830; *d.* 7 May 1879]

Amateur. Bengal Infantry 1850; joined Political Service 1862, serving in Udaipur, from where his first known photographs originate. From December 1862 to 1865 he was assistant to the Resident of Nepal at Kathmandu and here he took a series of architectural and ethnographical studies which are perhaps the earliest photographs taken in the country. Some of these won a medal at the 1864 Bengal Photographic Society Exhibition. In 1869 he was appointed an ADC to the Viceroy Lord Mayo. Retired 1875

Townshend, J.C. [*fl.* 1890s–1900s]

Commercial. Photographer and artist at Kampti from about 1893–1904. In the early 1890s he made a photographic documentation of the construction of the Bengal and Nagpur Railway.

Tripe, Major-General Linnaeus [b. Plymouth 14 Apr 1822; d. Plymouth 2 Mar 1902]

Amateur. Madras Army 1839–1875. Tripe probably took up photography in the late 1840s and served as official photographer with the British Mission to the Court of Ava in 1855, during which he produced a portfolio of 120 views of Burmese architecture and landscape. From 1856–1858 he was Presidency Photographer in Madras, producing architectural views which later appeared in the following publications, all issued in 1858: *Photographic views in Madura* (48 plates), *Photographic views of Poodoocottah* (10 plates), *Photographic views of Ryakotta and other places in the Salem district* (10 plates), *Photographic views of Seringham* (9 plates), *Photographic views in Tanjore and Trivady* (23 plates), *Stereographs of Madura* (70 plates), *Stereographs of Trichinopoly* (70 plates).

Tytler, Robert Christopher [b. Allahabad 25 Sep 1818; d. Simla 10 Sep 1872] *and* Harriet Christina [b. Sikora 3 Oct 1827; d. Simla, 24 Nov 1907]

Amateur. Robert Tytler entered the Bengal Army in 1834 and took part in several campaigns before playing an active role at Delhi during the Mutiny. His wife Harriet was one of the few women present at the siege of Delhi and at the conclusion of hostilities Robert Tytler took up photography in order to assist his wife in the painting of a panorama of the Palace. He received some tuition from Felice Beato and John Murray and in the course of six months in 1858 the couple made over 500 large format paper negatives of locations associated with the Mutiny, particularly at Delhi, Meerut, Cawnpore, Lucknow, Benares and Agra. These, when shown at a meeting of the Photographic Society of Bengal in March 1859 were considered as 'forming perhaps the finest series that has ever been exhibited to the Society.'

Waterhouse, Major-General James [b. London 24 Jul 1842; d. Eltham 28 Sep 1922]

Amateur. Royal (Bengal) Artillery 1859–1897. Joined Survey Department 1866, becoming Assistant Surveyor-General in charge of the Photo-Zincographic Office, Calcutta 1881. From November 1861 to December 1862 Waterhouse was seconded to photographic duties to take ethnographical photographs in the Central Provinces, during which commission he also made a series of views of the Great Stupa at Sanchi. A number of his photographs appear in John Forbes Watson and John William Kaye, *The People of India* (8 vols, London, 1868–1875). Waterhouse was officer in charge of the Indian Eclipse Expedition to the Nicobar Islands in 1875 (see his *Report on the operations connected with the observation of the total solar eclipse of April 6, 1875, at Camorta, in the Nicobar Islands* (Calcutta, 1875), illustrated with 6 original albumen prints) and in the course of his professional work made an outstanding contribution to research in photography and photomechanical reproduction, particularly in its cartographic applications. He served as President of the Photographic Society of India, 1894–1897 and of the Royal Photographic Society 1905–1906.

Wiele & Klein

Commercial. Studio established in Madras in 1882 by E.F.H. Wiele and Theodore Klein, with an Ootacamund branch managed by Klein in the 1890s–1900s. The firm became Klein and Peyerl in 1926 and was still trading in Madras in the 1960s.

Williams, F. Fisk [fl. 1850s–1860s]

Amateur. Assistant at R.C. Lepage & Co. A member of the Photographic Society of Bengal in the 1850s and author of a number of papers on photographic topics on the society's journal. One of his photographs of the effects of the Calcutta cyclone of 1864 was reproduced in the *Illustrated London News* (19 Nov 1864). Williams was the author of one of the earliest manuals on Indian photography, *A guide to the Indian photographer* (Calcutta, 1860).

Nineteenth-Century Photographic Processes

The daguerreotype in India

The daguerreotype was the first practical photographic process to be publicly announced and the precision and exactitude of this replication of the physical world on a silver-plated copper plate created a sensation when it was revealed to members of the French Academy in Paris by François Arago in August 1839. The result of years of experimentation by Louis Jacques Mandé Daguerre, the process involved burnishing a silver-plated copper sheet to a perfect reflective finish before exposing it to iodine vapour in a small box. This caused a thin deposit of light-sensitive silver iodide to form on the surface of the plate. After exposure in the camera, the invisible or 'latent' image was developed in fumes of mercury, which coalesced as a white amalgam of silver and mercury over those parts of the image which had been exposed to light. After fixing, the plate (often hand-coloured) was then mounted behind glass and cased in order to protect the extremely delicate surface from abrasion, dirt and chemical contamination. News of the process travelled swiftly from Europe to India and by early 1840 William Brooke O'Shaughnessy was using the process to great acclaim in Calcutta. Daguerreotype studios flourished in major metropolitan areas like Calcutta and Bombay up to the late 1850s, but by the end of the decade the process was becoming superseded by photography on paper. By the early 1860s the daguerreotype was all but dead.

While the daguerreotype produced an image of startling precision and often great beauty, its demise was the result of disadvantages inherent in the process itself. Its bright reflective surface was difficult to view in certain lights and the fact that it was a mirror image meant that the picture was laterally reversed (a fact which was no doubt partially responsible for the scarcity of landscape subjects compared to portraits). But perhaps its fatal drawback was the fact that every daguerreotype was a unique image: if more copies were required, it was necessary to make further exposures. The paper processes, with their potential for unlimited duplication from a single negative, were originally more imperfect than the daguerreotype in terms of sharpness, but they possessed critical advantages which ultimately won the day.

The Calotype

William Henry Fox Talbot had made the earliest known photographic negative in England in August 1835, but had abandoned his experiments until spurred into renewed activity by the appearance of the daguerreotype. By September 1840, after a period of intense work, he had made the most important of the discoveries which formed the basis of the Talbotype or calotype process: this was the developing-out of the latent image formed in the camera on a sheet of paper coated with light-sensitive silver iodide. This developed negative was then chemically fixed in sodium thiosulphate ('hypo') to remove unexposed and undeveloped silver compounds. From this paper negative positive images could be made using the salt print process. This involved floating or submerging good-quality drawing paper in a bath of sodium chloride, which after drying was refloated in a bath of silver nitrate, resulting in the formation of light-sensitive silver chloride in the top surface of the paper. This paper was mounted in a frame in contact with the paper negative, and exposed or 'printed out' in sunlight until the required density of image had been attained. No further chemical development was necessary: the positive image was made visible using the power of sunlight alone to reduce the silver salts to their pure metallic state. The resulting image, unless further treated, had little gloss or shine, and since the fibres of the paper negative through which the print was made tended to soften outline and lower overall contrast, such prints often resemble non-photographic processes such as mezzotints or soft-ground etchings. The calotype process was the subject of considerable experimentation during its life. Perhaps the most important modification was Gustave Le Gray's waxed paper process, in which the paper was impregnated with heated wax prior to sensitisation, thus increasing transparency and hence definition and altering the tonal values of the final print. Alternatively, many photographers (such as Tripe, Murray and Biggs in India) waxed their negatives after processing. With its broad and subtle tonal range, the calotype was at its finest capable of an expressive delicacy which remains unsurpassed. The earliest surviving paper prints from the subcontinent – among them those of Alfred Huish, John McCosh and Frederick Fiebig, were all produced from paper negatives, and in the second half of the 1850s, the paper negative process was taken to new heights of technical and aesthetic excellence in the hands of masters such as John Murray and Linneaus Tripe.

By the end of the 1850s, however, glass was rapidly replacing paper as a negative support and while the portability and ease of the paper processes were a particular advantage in India, the calotype quickly lost ground to the wet collodion negative process on glass.

The Wet Collodion Process

While the delicate beauties of the calotype

process are prized today, for many nineteenth-century photographers it lacked the precision and almost microscopic rendition of detail so apparent in the daguerreotype and which for many (for whom photography's abiding fascination was its fidelity in reproducing the forms of the external world) was its chief aim. In 1851 Frederick Scott Archer's wet collodion process was made public. In this procedure, the light-sensitive silver iodide salts were formed and held within a thin layer of collodion, which in a procedure requiring considerable dexterity, had been carefully coated onto a sheet of glass. Whereas in Talbot's process the chemical compounds were held within the cellulose fibre of a sheet of paper, in Archer's they were retained within the permeable stratum of collodion. Thus the collodion film, supported on a completely transparent glass base, produced a textureless image of remarkable quality and sharpness. The wet plate process (so called because the glass plate had to be coated, exposed and developed in a single sequence before the collodion dried out) required considerable technical skill and experience to master (particularly in the heat of an Indian dark tent), but its advantages of sensitivity and definition meant that for thirty years or more (when it in turn was overtaken by the more convenient dry plate process), it was by far the most widely used of the available photographic techniques.

Just as the paper negative gave way to glass, so the salt print was overtaken by the albumen print as the standard medium for making positives from glass negatives and by the early 1860s had largely ousted the salt print. Its introduction is generally attributed to the Frenchman Louis-Desiré Blanquart-Evrard. Although both type of print belong to the same generic group of 'printing-out processes', the albumen print is most often characterised by having a deep gloss finish. From the 1850s up to the late 1890s, when it started to be replaced by a variety of papers capable of being produced by automated systems, the overwhelming majority of photographs were produced on albumen paper. As with salt prints, the first stage was to lay down an even coating of either sodium of ammonium chloride. This was achieved by floating a sheet of paper in a bath containing a mixture of albumen (egg white) and salt. The sheet was then floated on a bath of silver nitrate, thus forming the light sensitive layer of silver chloride. The first bath gave the paper its characteristic gloss and by sealing the pores of the paper, also held the silver sensitised layer on the surface. The paper was then printed in sunlight in a similar manner to the salt print. Prior to fixing, the print was passed through an alkaline gold toning bath to preserve the whites and maintain good coloration in the shadow areas. Varieties and length of toning, the subject of a huge amount of experimentation in India as elsewhere, could produce a wide range of colours and contrast in the final print, from the warmest browns to purple and black, as well as having an important effect on the long-term stability of the print.

If the aesthetic qualities of the paper negative had made it the medium of choice of the self-consciously artistic amateurs of the 1850s, the professional photographers of succeeding decades worked almost exclusively with glass and albumen to produce the sharply-detailed glossy images most popular with the print-buying public. But although collodion and albumen were the dominant tool of the photographer up to the 1890s, the vast range of available techniques used at one time or another during this period – from the delicate and distinctive grey tones of the platinum print, to the wide range of colours produced by various pigment prints – should not be entirely overlooked. Particularly fine examples of the former are to be seen in the work of Shamarandra Chandra Deb Barmar, whose platinum prints won numerous prizes both in India and England in the 1890s.

Papers presented in the journals of the photographic societies of Bombay, Calcutta and Madras in the 1850s and 1860s supply ample evidence of the ceaseless experimentation undertaken by photographers in the sub-continent to realise an artistic vision as well as to adapt standard chemical and photographic procedures to the exigencies of the Indian climate and the effects of heat and humidity on often delicate manipulations. This bald summary does little justice to a multiplicity of techniques developed and discarded in the course of the second half of the nineteenth century and it should finally be emphasised that such developments did not take place as sharply defined technical advances. Processes overlapped and were amalgamated in a continuum – for instance, John Murray's paper negative views were printed both as salt and albumen prints and the paper negatives made by Thomas Biggs in 1855, were printed on albumen paper when they were finally published a decade later.